THE SUCCESS
AND FAILURE
OF
PICASSO

JOHN BERGER

THE SUCCESS AND FAILURE OF PICASSO

WITH 120 ILLUSTRATIONS

PANTHEON BOOKS, NEW YORK

LIBRARY OF CONGRESS CATALOGING IN PUBLICATION DATA

Berger, John.
The success and failure of Picasso.

 Reprint of the 1965 ed. published by Penguin Books,
Harmondsworth, Eng.
 1. Picasso, Pablo, 1881–1973. I. Title.
[ND553.P5B45 1980] 759.4 79-3616
ISBN 0-394-73900-0

Manufactured in the United States of America
23456789

759.6
P 58be

A

I dedicate this book to my Anya, to Ernst Fischer, and to the memory of Max Raphael,* a forgotten but great critic. The three of them persuaded me.

* *Proudhon, Marx, Picasso* (Excelsior Press, Paris, 1933).

I would like to acknowledge the help of Tony Richardson throughout all stages of the production of this book – and especially for all his work in the tracing and collecting of the plates. J.B.

The publishers are grateful to Mrs W. B. Yeats and Messrs Macmillan for permission to reproduce the poem *Crazy Jane on the Day of Judgment* from *Collected Poems of W. B. Yeats.*

In the majority of cases photographs have been obtained from the institutions acknowledged in the list of illustrations. For permission to use other photographs we are indebted as follows: to Studio Alfieri for illustration 14; to Mariette Lachaud for 17; to the Arts Council for 18, 23, 42, 99, 100 and 106; to Giraudon for 52 and 66; to Éditions Cercle d'Art for 68; to Jean Mohr for 91; and to Galerie Louise Leiris for 103, 105 and 107-20.

ILLUSTRATIONS

THE SUCCESS
AND FAILURE
OF
PICASSO

1

PICASSO

is now wealthier and more famous than any other artist who has ever lived. His wealth is incalculable. I will mention only one of his assets. He has a collection of several hundred of his own oil paintings, kept from all periods of his life. This collection – on the basis of current prices – must be worth anything between five and twenty-five million pounds.

Last year one of his gouache paintings (normally worth less than an oil), measuring about two feet by three feet, was re-sold at an auction for £80,000. Admittedly this picture was painted in 1905 during the so-called Blue Period, and this period, because it deals pathetically with the poor, has always been the favourite amongst the rich. However, a small, very average still-life painted in 1936 recently fetched over £10,000. Since Picasso's collection of his own work includes at least five hundred canvases, many of them much larger and more important than the still-life, this gives us the absolute minimum of five million. The works would, of course, have to be sold *tactfully* – so as not to flood the market too abruptly.

Just after the Second World War Picasso bought a house in the South of France and paid for it with one still-life. Picasso has now in fact transcended the need for money. Whatever he wishes to own, he can acquire by drawing it. The truth has become a little like the fable of Midas. Whatever Midas touched, turned into gold. Whatever Picasso puts a line round, can become his. But the fable

3

was a comic-tragic one; Midas nearly starved because he couldn't eat gold.

It was in the early 1950s that Picasso's earning power and wealth became fabulous to this degree. The decisions which so radically affected his status were taken by men who had nothing to do with Picasso. The American government passed a law which allowed income-tax relief to any citizen giving a work of art to an American museum: the relief was immediate, but the work of art did not have to go to the museum till the owner's death. The purpose of this measure was to encourage the import of European works of art. (There is still the residue of the magical belief that to own art confirms power.) In England the law was changed – in order to discourage the export of art – so that it became possible to pay death duties with works of art instead of money. Both pieces of legislation increased prices in salerooms throughout the art-loving world.

There was another reason for the rise in prices. By the early 1950s the amount of money available for investment had increased to an unprecedented degree. The reconstruction after the war, the stimulus of rearmament, the consolidation of the developed economies at the expense of the underdeveloped ones, had all led to a situation where there was capital to spare. This in itself would have stimulated art investments, but there was an additional – one might almost say more human – motive involved.

The possibilities of foreign and colonial investment had changed since pre-war days. The sums involved were now too vast for the average private investor to take private decisions: now he simply handed his capital over to a highly-organized investing group. Monopoly capitalism becomes anonymous in character for the average investor no less than for the average employee. Consequently there were investors who were looking – as a sideline – for a field of investment which offered a chance of personal interest and excitement, whilst still remaining comparatively safe. Some of them found art. And so art, at about this time, took in certain lives the place that was once occupied by South American railways, Bolivian tin, or tea plantations in Ceylon.

Within ten years the prices in the art salerooms increased at least tenfold.

4

Yet even before the 1950s Picasso was rich. Dealers began to buy his work in 1906. By 1909 he employed a maid with apron and cap to wait at table. In 1912, when he painted a picture on a whitewashed wall in Provence, his dealer thought it was worthwhile demolishing the wall and sending the whole painted piece intact to Paris to be remounted by experts on a wooden panel. In 1919 Picasso moved into a large flat in one of the most fashionable quarters of Paris. In 1930 he bought the seventeenth-century Château de Boisgeloup as an alternative residence.

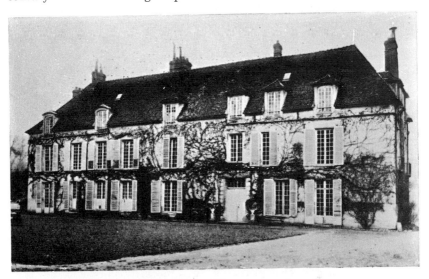

From the age of twenty-eight Picasso was free from money worries. From the age of thirty-eight he was wealthy. From the age of sixty-five he has been a millionaire.

His reputation has increased in step with his wealth. Originally of course it preceded it: it was Picasso's reputation amongst his friends and fellow painters which first brought him to the attention of the dealers. Today it is his wealth that helps to increase his reputation.

His name is known to those who could not name their own Prime Minister. He is as famous in England as Raphael is in Italy. He is as famous in France as Robespierre. One of his friends, the critic Georges Besson, goes much further.

'Nothing', he says, 'is riskier than trying to define Picasso the man, more famous than Buddha or the Virgin Mary, more mercurial than a crowd.' This, as so often with Picasso's friends today, is an exaggeration. But certainly no painter has ever been known to so many people.

The mass media are the technical explanation of this. When once a man has, for some reason or another, been selected, it is they who transform his public from thousands into millions. In the case of Picasso this transformation has also changed the emphasis of his fame. Picasso is not famous as Millet in France or Millais in England were famous eighty years ago. They were famous because two or three of their paintings were made popular and reproductions of these pictures hung in millions of homes. The titles of the paintings – *Cherry Ripe* or *The Angelus* – were far better known than the name of the painter. Today, if you take a world view, not more than one out of every hundred who know the name of Picasso would be able to recognize a single picture by him.

The only other artist the extent of whose fame is comparable with Picasso's is Charlie Chaplin. But Chaplin, like the nineteenth-century painter, became famous because of the popularity of his work. Indeed there are many stories of how his public were disappointed when they saw the real Chaplin because they expected to see Charlie, complete with moustache and walking stick. In Chaplin's case, the artist – or rather his art – has counted far more than the man. In Picasso's case the man, the personality, has put his art in the shade. It is too early to explain why this has happened. But it is a point we shall come back to again and again.

You may say that to recognize a name doesn't amount to recognizing a personality. But everything remembered trails and attracts associations. The associations around

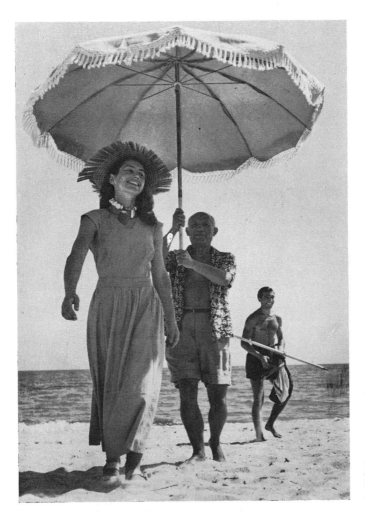

2 *Picasso and
Françoise
Gilot at Golfe
Juan, 1948*

Picasso's name create the legend of the personality. Picasso
is an old man who can still get himself young wives.
Picasso is a genius. Picasso is mad. Picasso is the greatest living
artist. Picasso is a multi-millionaire. Picasso is a communist.
Picasso's work is nonsense: a child could do better. Picasso
is tricking us. If Picasso can get away with it all, good luck
to him! Such is an average combination of the associations of
the name in Europe. The apparent contradictions are

possible – even necessary – because daily logic need not and should not apply to mythological characters.

You suspect I am exaggerating? In the last fifty years under the inhuman pressures within bourgeois society a terrible thirst for unreason has been developed. Jaime Sabartes is Picasso's life-long companion and semi-official biographer. This is how Sabartes projects Picasso, the man, into the legendary world of the gods:

If Picasso could detain the course of time, all clocks would stop, the hours would perish, days would come to an end, and the earth have to cease its revolutions and wait for him to change his mind. And if it had really been he who had stopped it, the globe would wait in vain. Thus I found Picasso, and thus he must continue. It is necessary for the free pursuit of his destiny.*

Surprising as it may at first seem, the expert view of Picasso is, in essence, very similar to the popular view. The experts may admire his art, but, whenever they can, they present Picasso as something other than – or more than – a painter.

The Spanish poet Ramón Gomez de la Serna wrote about his friend in 1932:

In Malaga, his native town, I found an explanation of what Picasso is and I understood to what degree he is a toreador – gypsies are the best toreadors – and how, whatever he may do, it is in reality bullfighting.

Jean Cocteau wrote in the late 1950s:

A procession of objects follows in Picasso's wake, obeying him as the beasts obeyed Orpheus. That is how I would like to represent him: and every time he captivates a new object he coaxes it to assume a shape which he makes unrecognizable to the eye of habit. Our shape-charmer disguises himself as the king of the rag-pickers, scavenging the streets for anything he may find to serve him.

I, more than most, appreciate the difficulty of writing about painting in words and the need for images and metaphors. But the images which Picasso's friends use all tend

* This and the quotation on pp. 11-12 are both taken from one of the most popular of the expensive books on Picasso: *Picasso*, by Wilhelm Boeck and Jaime Sabartes (Thames & Hudson, 1961).

to disparage the mere art of painting. The more one reads them, the more one feels that Picasso's actual works are incidental. One of his friends – Manolo the Spanish sculptor – said this quite simply: 'For Picasso, you see, painting is a side-issue.'

This would make better sense if Picasso had many other interests, and divided his energies between painting and other activities. It would even make sense if Picasso was an excessively social man who primarily expressed himself in his relationships with other people. But none of this is the case. He is single-minded; he works like a man possessed; and all his relationships are more or less subservient to the needs of his art.

What then is the explanation? Picasso is fascinated by and devoted to his own creativity. What he creates – the finished product – is almost incidental. To some degree this is of course true of all artists: their interest in a work diminishes when it is finished. But in Picasso's case it is very much more pronounced. It even affects the way he works. He denies that there is such a thing as progress in the creation of a painting: each change, each step, each metamorphosis – as he calls it – is merely a reflection of a new state *in him*. For Picasso, what he *is* is far more important than what he *does*. He projects this priority on to all art:

It's not what the artist does that counts, but what he is. Cézanne would never have interested me a bit if he had lived and thought like Jacques-Émile Blanche, even if the apples he had painted had been ten times as beautiful. What forces our interest is Cézanne's anxiety, that's Cézanne's lesson; the torments of Van Gogh – that is the actual drama of the man. The rest is a sham. *

Certainly neither Cézanne nor Van Gogh would have agreed with this. Both, in their different ways, were obsessed by what they produced; both knew that it was by their works and their works alone that their lives might be justified. Cézanne said, 'The only thing that is really difficult is to prove what one believes. So I am going on with my researches. . . .'

* This and most of the other quotations from statements by Picasso are taken from the very well documented *Picasso: Fifty Years of His Art*, by Alfred H. Barr (Museum of Modern Art, New York, 1946).

Picasso's attitude would, however, have found an echo with the early Romantics – who were indeed the first to formulate it. For them the creative spirit was supreme, and its concrete expressions not just incidental, but a vulgarity.

> Heard melodies are sweet, but those unheard
> Are sweeter. . . .

At the beginning of the nineteenth century this was a *necessary* belief; it was what allowed artists to continue when faced with the way in which the ever more powerful bourgeois world was reducing everything, including art, to a commodity. The creative spirit, genius as a state of being, was celebrated as an end in itself because it alone did not have a price and was unbuyable.

This dualism is now at the very heart of the bourgeois attitude to art. On one hand, the glory and mystery of genius; on the other hand, the work of art as a saleable commodity. You have only to listen to any art dealer today to hear the two in grotesque juxtaposition. The bargaining in guineas, the guarantees of investment, and then the adjectives ('exciting', 'powerful', 'extraordinary', 'fantastic') applied to the intangible quality of the work.

It is also implicit in the popular image of the genius – as it is encouraged by untruthful books and films. The genius cannot look after his own material interests (on account of madness, unworldliness, drink), and this inability comes to be seen as a *proof* of his genius.

One finds the same dualism – the last legacy of this Romantic illusion – in what is now the standardized method of writing art books. The pictures, which the reader can see in the reproductions, are painstakingly described – as though for an inventory. They are treated as stock. Into this description are then inserted the phrases which confer genius on the producer of the pictures. The phrases mount like an incantation. The writer becomes a kind of priest as auctioneer. Here is a typical example:

10

3 *Picasso.*
An Old Man.
1895

The half-length portrait of an old beggar dating from that time discloses advanced technical skill. There is no doubt that in this as in other related early paintings Picasso was inspired by the great paintings of Velazquez, such as the famous *Water Seller of Seville*. That is the source of the magnificently realistic rendering of the shining skin, the pasty hair, and the coarse clothing of his model, as well as of the generous, broad brushwork vigorously juxtaposing lights and shadows, which stresses the momentary quality of the figure, and largely contributes to the serious concentrated expression. On the other hand nothing in this picture suggests

11

imitation, let alone copying: like Picasso's later works, even this youthful painting is characterized by the extraordinary intensity of his own effort. And like all his paintings inspired by historical models, this one reveals a mind that consumes the thing seen in the fire of enthusiasm and recreates it from the ashes as something new that belongs to Picasso alone. . . .*

What is said is not untrue. It is simply irrelevant. (What might be relevant is why painters paint beggars, what is special about the Spanish attitude to poverty, how the age of a man changes the clothes he wears, whether or not Picasso when he painted this at the age of fourteen was already becoming aware of the inadequacy of the provincial, illustrative style of drawing he had been taught, etc.) There is a total inability to see the work in relation to any general human experience. Instead, the picture is described, identified, and given a good pedigree as an object; whilst Picasso – at the age of fourteen – is set at Velazquez' right hand and glorified as a phoenix-like genius.

Yet although this Romantic illusion has been preserved in the bourgeois attitude to art, it has not continued to be accepted by artists. For the early Romantics it was a working hypothesis of faith which allowed them to continue working. By the middle of the nineteenth century – and increasingly towards the end – a new and more realistic hypothesis was being put forward. The power of the bourgeoisie would not last for ever. Society was changing or would be changed. The future would therefore be different. From this one could draw the conclusion that the important artist was *ahead of his time*. Stendhal was among the first to draw this conclusion when he prophesied that his work would start being read in 1880 and appreciated in 1935.

From Stendhal onwards every major artist, however Romantic he may have been in other respects, believed that his works – the only things which could survive in the future – were the justification of his life. He struggled to put all of himself into his work; his creative spirit, in so far as he thought about it, was merely his ability to do this, to transform what he *was* into what he *made*. This is as true of Flaubert as of Cézanne or Gauguin or Seurat or Van Gogh or Rodin or Yeats or James Joyce. A few minor

* See footnote, p. 8

artists – like Maeterlinck – played with reviving the romantic illusion about silence being more musical than sound; but it was no longer a means of working: it was a way of graciously accepting defeat at the hands of the world.

The important artists of Picasso's generation shared the attitude of their predecessors. Indeed part of their admiration for Van Gogh or Cézanne was due to their sense of having inherited their work, which it was now their duty to continue and develop further. All the emphasis was on what had been and had to be done. As they became highly successful – like Matisse or Braque – they may have needed to believe in their justification by working less urgently. But one has only to read those who, like Juan Gris or Apollinaire, died before such success came, to realize how fundamental to this generation was their conviction that it is what the artist *does* that counts. A little before he died in 1918, Apollinaire wrote an essay on the new spirit of the poets.

There is the material the poet has collected, the material the new spirit has revealed, and this material will form the basis of a truth the simplicity of which will be undeniable, and which will lead to great, very great things.

The life-line runs through the work.

But not for Picasso. Picasso is the exception. 'It's not what the artist does that counts but what he is.'

We have here the first indication of Picasso's historical ambiguity. He is the most famous painter in the world and his fame rests upon his modernity. He is the undisputed emperor of modern art. And yet in his attitude to art and to his own destiny as an artist there is a bias which is not in the least modern and which belongs more properly to the beginning of the nineteenth century.

Furthermore there seems to be a connexion between this historical ambiguity and the nature and scale of his success. The popular myth of Picasso, supported by the evidence of his friends, is not in fact such a gross distortion of the truth as seen by Picasso. Picasso's own Romantic belief in genius as a state of being lends itself to the myth. The working attitude of any of his great contemporaries, their temperamental treatment of themselves, would never have fed the myth with enough material. But with Picasso's

13

example it is only a few steps from genius as a state of being
to the divinity of the demi-god.

I don't want to suggest that Picasso's legendary character
is simply the result of his own opinions about what it
means to be an artist. He has an extremely powerful
personality which provokes legends. Perhaps he is a little
comparable in this respect with Napoleon. Certainly he has
a similar power of attracting and holding allegiance. He is
very seldom criticized by those who know him personally.
What Picasso is, apart from what he does, is indeed remark-
able – and perhaps all the more so for being indefinable.
It is not how he speaks or acts that seems to be so memor-
able: it is his presence – the hint of what is going on inside
the man.

In recent years all accounts of Picasso as a personality
have become absurd. He has surrounded himself with a
court, and he is king. The effects of the consequent flattery
and insulation have been devastating, not only on the
judgement of all those who know him, but on his own work.
A special kind of sickening poeticizing has been invented
for the homages. Thus Georges Besson wrote in 1952:

I almost forgot to tell you – or have I told you already? – that
this man, whose tastes are not extravagant, has a weakness
for black diamonds. He owns two superb ones and he will never
part with them. They weigh a good hundred carats each.
He wears them where other people have eyes. It's as I tell
you. And I assure you that those women on whom these
diamonds turn their fire are utterly bowled over.

But before he had courtiers, those who wrote about
Picasso found his eyes particularly remarkable. Fernande
Olivier, describing how she first met him in 1904, wrote:

Small, black, thick-set, restless, disquieting, with eyes dark,
profound, piercing, strange, almost staring.

His eyes [wrote Gertrude Stein, referring to about the same
period] were more wonderful than even I remembered, so
full and so brown, and his hands so dark and delicate and alert.

In 1920, when Maurice Raynal was disappointed with
Picasso's latest exhibition, he wrote: 'Some of the stars in
his eyes have gone out.'

The eyes in the head become a symbol for the whole man. In the films about Picasso you can see his eyes for yourself. They reveal – or so it seems to me – the inordinate intensity of the man's inner life and at the same time the solitariness of that life.

Little by little we are being forced to consider the general nature, the trend of Picasso's subjective experience. How to define this spirit which he himself values more than his work, which charges his presence, and which burns in his eyes?

Picasso was born in Malaga in 1881. From Malaga you can see the Atlas mountains and, when the wind is in the south-east, you can smell the desert. Picasso's ancestors, on both sides of his middle-class family, had belonged to Malaga for several generations. In 1900, when he was nineteen years old, Picasso left Spain for the first time in his life and spent a few months in Paris. In 1904 he settled in Paris permanently. Between 1904 and 1934 he returned to Spain about half a dozen times on holidays and painting trips. Since 1934, when Picasso was fifty-three, he has never been back. Picasso has spent most of his life in voluntary exile.

Exile is a state which, in its subjective effects, never stands still: you either feel increasingly exiled as time passes, or increasingly absorbed by your adopted country. Picasso certainly adopted France, and France him. His friends were French, he spoke in French, and he came to write in French. He was able to share in French patriotism. (Patriotism – as a result of the three German invasions of French territory in 1870, 1914, and 1940 – was a far more important element in French intellectual life than in English intellectual life during the same period.) France, on her side, recognized Picasso's genius, and created his reputation for the world to take over in 1945. Nevertheless, and despite all this, I believe that Picasso has felt increasingly exiled.

His deepest needs have not been met in France. He has remained solitary. Loneliness is so common today in the metropolitan world of Western Europe and North America that the term has to cover a multitude of varieties. Old-age pensioners are lonely on park-seats. Old millionaires are said to be lonely as they look out at the world through their

15

curtained windows. Some suffer loneliness in a crowd, others become lonely when there is not a soul in sight. We comfort ourselves by saying that it is also the privilege of great men to be lonely. But Picasso's loneliness, if I am right, does not fit into any of these categories. He is lonely in the same way as a lunatic is lonely: because it seems to the lunatic that, since he never meets opposition, he can do anything. It is – by a paradox – the loneliness of self-sufficiency. This is not necessarily a loneliness that is suffered directly; more often it is a loneliness that provokes ceaseless activity and gives no rest. The worst thing in an asylum is that there is so little natural sleep. Perhaps it is foolish of me to use this image because it may confirm the philistine idea that Picasso is mad. He is not mad. Yet there is no other comparison which can illustrate so clearly what I mean. To explain why this should be so we must consider what Picasso has been exiled from: the Spain of his childhood and youth.

Picasso lived in Malaga until he was ten. Then the family moved to Corunna on the north Atlantic coast of Spain. When he was fourteen they moved again to Barcelona. Each of these cities is very different from the others – climatically, historically, and temperamentally. One of the difficulties of writing about Spain is that there are several Spains. Spain – in economic and social terms – has not yet achieved its unity. People speak of two Italies – north and south of Rome. One would have to speak of half a dozen Spains. This point is of crucial importance because it reminds us that Spain is historically behind the rest of Europe. Spain is separate.

Its geographical position and the fact that it is part of Christendom tend to deceive us. It would be truer to say that Spain represents a Christendom to which no other country has belonged since the Crusades. As for its geographical position, it might – if viewed with a fresh eye – be compared with Turkey's. Certainly there is the Spanish contribution to European culture, but this also is deceptive. It is limited to literature and painting. It does not include the arts or sciences which are more directly dependent on comparable forms of social development; Spain has contributed little to European architecture, music, philosophy, medicine, physics, or engineering. Even, I would suggest,

16

Spanish painting and literature have had less effect in Spain than outside Spain. They have belonged to those who could afford a vision of a way of life as it was lived in Europe, beyond the Pyrenees.

4 *Spanish landsape*

Spain is separate because Spain is still a feudal country. Seventy years ago, when Picasso was a boy, this feudalism was considerably less modified than today. Then, more than three quarters of the workers worked on the land. Their tools were primitive and the division of labour was only in a preliminary stage. In many areas production was only

5 *Spanish peasants harvesting peppers*

for household or village use. Compulsory labour-service was exacted, in various forms, by landlords from tenants. The landlords, by means of the '*cacique*' system, had what amounted to judicial power of life and death over the peasants. These are all classic symptoms of feudalism. But pure classic feudalism is probably an abstraction. The Spanish variety at the end of the last century was complicated and impure.

I am not equipped to unravel Spanish history here. But with a few rough generalizations and one or two examples I must attempt to suggest, however briefly, the period of Spanish development into which Picasso was born. Only then, I believe, have we a hope of understanding his spirit.

Spanish feudalism was complicated, distorted – in two opposed ways. On one hand there was a great deal in Spain

18

which was pre-feudal; on the other hand there existed a very large administrative middle class – comprising nearly one fifth of the population.

The pre-feudal 'relics' were mostly to be found in isolated and inaccessible rural areas – but this term covers most of the land in Spain. In the Basque country and Navarre, for example, there was a system of land tenure in operation dating back to the tenth century and based on the clan system. On the vast, largely unworked estates in Andalusia, the labour system had more in common with Roman slavery than medieval feudalism. On the central plateau of Spain the sheep-farmers and cattle-breeders of Castile led a life which was essentially nomadic and tribal. But perhaps the most important 'relic' of all was to be found in the consciousness of the average Spanish peasant. Somehow he *remembered* a communal way of life – its exact form of organization varying greatly from province to province. This memory, combined with his bitter and unchanging poverty, made him despise private property and cling to an idea of freedom – which had nothing whatsoever to do with the *liberté* of the French Revolution, but which was the freedom and pride of the individual within a primitive, spontaneous, and small collective. He was the peasant who later, in the Civil War, wished to destroy all money.

The Spanish middle classes were born with the bureaucracy which was established in the sixteenth century to administer the Inquisition, the South American colonies, and the occupied territories in Italy and northern Europe. From the beginning, this bureaucracy was unproductive and vast in scale. A century after its formation the Venetian ambassador to Madrid wrote as follows:

Everyone who can, lives at the expense of the State. The number of all the government posts has been increased. In the Treasury alone there are more than 40,000 clerks, many of whom draw twice the pay that is assigned to them. Yet their accounts are wrapped in impenetrable and perhaps malicious obscurity and it is impossible to get any order or number out of them.

At the same period there were 24,000 tax collectors and 20,000 in the pay of the Inquisition. Such figures give some idea of the economic unreality of this class.

19

At first South American gold and Flemish industries paid for its maintenance. Later, as Spanish power declined, the burden was transferred to the Spanish economy itself, which was totally incapable of bearing it. Chronic impoverishment set in; there was no attempt to develop the economy, because this so-called middle class did not understand the link between capital and production: instead they sank back into provincial improvidence, proliferating only their 'connexions'. By the middle of the last century every village postman owed his position – through a long chain of intermediaries – to a Minister in Madrid. When the government fell, the postman lost his job to a 'supporter' of the next government.

This is the general, typical history: there were exceptions. By Picasso's time capitalist industrial enterprises had been started in the north, though still on a small scale. The middle-class young had joined the army and made *junta* plans to 'modernize' Spain. There was a liberal and European-orientated tradition in certain professions. In 1873 a Republic had been proclaimed, but it had lasted for only one year.

What I want to establish is that the Spanish middle class, among whom Picasso was brought up, had – even if they wore the same clothes and read some of the same books – very little in common with their French or English or German contemporaries. Such middle-class virtues as there were in Spain were not created of *necessity*: if they existed, they were cultivated theoretically. There had been no success-ful bourgeois revolution. In an absolutist state the middle class had no independent power and so the virtues of initiative, in-dustriousness, non-conformism, thrift, scientific curiosity, had no reason to exist. On the contrary the history of the Spanish middle class had encouraged the very opposite traits. The Inquisition had insisted upon the most rigid orthodoxy, both religious and racial: Jews and Moors were considered inferior races: a violent and hieratic snobbery had been developed. Equally, the state bureaucracy had discouraged initiative and put a premium on safe laziness. It came to be thought that to work hard was to lose one's dignity. The energy of the Spanish middle class was turned to ritual, which bestows on events a significance gathered from the past and precludes innovation or the thought of it.

6 *Easter
procession in
Lorca*

Yet at the same time it must be remembered that
Spaniards had not paid the price of progress as it was being
paid in France or England. The wealthiest among them
were land-owners, not bankers. As a class they served the
Church, the estates, the army, and the absolute monarchy;
they did not serve capital. This meant that their lives,
although very provincially circumscribed, were not
depersonalized and made anonymous by the power of
money. (The cash nexus, which Carlyle was thundering
against in England in the 1840s, does not exist in Spain even
now.) It also meant that their class enemy was the peasantry,
not a proletariat. A proletariat has to be outwitted and

21

tricked; peasants can mostly be ignored and occasionally intimidated by force. Consequently, the Spanish middle classes were not forced to be hypocritical: they were not trapped between their professed morality and what they needed to do to survive. Because there was no class they had to trick, they could at least be honest to themselves. Within strict limits, they could be proud and independent and could trust their own emotions. (This partly explains why Spaniards have the reputation in the rest of Europe of being so 'passionate'.)

Spain then was separate. Its economy was predominantly feudal. The memories and hopes of its peasants were pre-feudal. Its large and unusual middle class, whilst maintaining many apparent connexions with contemporary Europe, had still not made the equivalent of a bourgeois revolution. The tragedy of Spain lay (and still lies) in this historical paradox. Spain is a country tied on an historical rack – the symbolic equivalent of its own Inquisition's instrument of torture. It is stretched between the tenth and the twentieth centuries. Between them there have not arisen, as in other countries, those contradictions which can lead to further development: instead there is unchanging poverty and a terrible equilibrium.

The typical modern political movement in Spain was anarchism. As a youth in Barcelona, Picasso was on the fringes of this movement. The anarchism that took root in Spain was Bakunin's variety. Bakunin was the most violent of the anarchist thinkers.

Let us put our trust in the eternal spirit which destroys and annihilates only because it is the unsearchable and eternally creative source of all life. The urge to destroy is also a creative urge.

It is worth comparing this famous text of Bakunin's with one of Picasso's most famous remarks about his own art. 'A painting', he said, 'is a sum of destructions.'

The reason why anarchism is typical of Spain and why it achieved a mass following in Spain to a degree which it achieved nowhere else, is that, as a political doctrine, it also is stretched on an historical rack. It connects social relations as they once were under primitive collective ownership with a millennium in the future which is to begin suddenly and violently on the Day of Revolution.

22

It ignores all processes of development and concentrates into a single, almost mystical moment or act all the powers of an avenging angel born of centuries of endured and unchanging suffering.

Gerald Brenan, in his excellent book, *The Spanish Labyrinth*, records the following incident during the Civil War:

I was standing on a hill watching the smoke and flames of some two hundred houses in Malaga mount into the sky. An old anarchist of my acquaintance was standing beside me.
'What do you think of that?' he asked.
I said, 'They are burning down Malaga.'
'Yes,' he said, 'they are burning it down. And I tell you, not one stone will be left on another stone – no, not a plant not even a cabbage will grow there, so that there may be no more wickedness in the world.'

This is typically Spanish: the belief that everything – the whole human condition – can be violently and magnificently changed in one moment. And the belief has arisen because nothing has changed for so long, because in the end the Spaniard is forced to believe in a magical transformation in which the power of the will, the power of the wishes of men still uncomplicated by the moral nuances of a civilization in which each hopes to save himself first, can triumph over all material conditions, can triumph over the slow accumulation of new productive means which in reality is the only condition of progress. The terrible equilibrium of the rack produces from time to time a terrible impatience.

There is also an economic logic to the old anarchist's outburst as he looks down at Malaga. (This logic does not necessarily enter his own considerations for he has long deserted logic – as any of us might if tied to the rack.) This is the logic of the fact that the Spanish ruling class have established nothing, have built nothing, have discovered nothing that can be of the slightest use to the peasants who are overthrowing them. Expropriate the expropriators! But here the original expropriators have added nothing to what they expropriated. There is only the bare land. This can once again be cultivated by a primitive collectivist commune. Everything else is *useless* – and therefore luxury and corruption are better burnt.

23

7 Spanish peasants returning from market

In such a situation it is inevitable that revolutionary energy becomes regressive: that is to say aims at re-establishing a more primitive but juster form of social relations, which frees men from human slavery but precludes them from the possibility of freeing themselves from the slavery of nature.

Picasso's painting *Guernica* is said to be a protest against modern war, and is even sometimes claimed to be a kind of prophetic protest against nuclear war. Yet at the time when Guernica was razed to the ground by German Junkers and Heinkel bombers, most of the anarchists in Andalusia who had collectivized the land were unable to 'expropriate' a single piece of agricultural machinery. Such is the rack.

Yet, you may say, Barcelona is not Andalusia; Barcelona is an industrial city and so surely the anarchism in which Picasso was involved was different? Superficially it was different. Picasso read Nietzsche and Strindberg.* The circle in which he moved was considerably influenced by Santiago Rusiñol, a painter and critic, who had issued the following *fin-de-siècle* order of the day:

Live on the abnormal and unheard-of . . . sing the anguish of ultimate grief and discover the calvaries of the earth, arrive at the tragic by way of what is mysterious; divine the unknown.

* For Picasso's cultural background in Spain, see *Picasso; The Formative Years*, by Phoebe Pool (Studio Books, 1962).

24

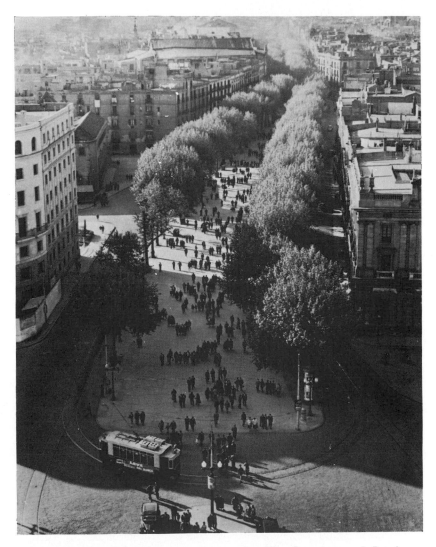

Nevertheless, Barcelona was not a city like Lyons or Manchester. The *fin-de-siècle* tone was adopted by some of its intellectuals because it was a provincial city trying to keep up with the capitals. But its own violence was real rather than imaginative, and its extremism was an everyday fact.

8 *Barcelona. Las Ramblas*

25

In 1906 Alezandro Lerroux, leader of the radicals in Barcelona, exhorted his shock-troop followers who called themselves the 'Young Barbarians' as follows:

Enter and sack the decadent civilization of this unhappy country; destroy its temples, finish off its gods, tear the veil from its novices and raise them up to be mothers to civilize the species. Break into the records of property and make bonfires of its papers that fire may purify the infamous social organization . . . do not be stopped by altars nor by tombs . . . fight, kill, die.

This is not very far from the old man looking down at Malaga. Neither of them can forgive. In Lerroux one can perhaps sense the beginning of fascism. But this word is often used too loosely. Incipient 'fascism' can exist whenever a class or a people feel sufficiently trapped. Fascism, in its modern and precise sense, applies to the exploitation of this feeling by imperialism and big business as a weapon against socialism. In Barcelona at the turn of the century this was not the case.

Barcelona was not fascist but simply lawless. Beginning in the 1890s bombs were being thrown. In 1907 and early 1908 two thousand exploded in the streets. A little after Lerroux's speech twenty-two churches and thirty-five convents were burnt down. There were a hundred or more political assassinations every year.

What made Barcelona lawless was once more the historical rack. Three groups of interests were each fighting for survival. There was Madrid fighting for its absolutist right, as established by the Habsburgs in the seventeenth century, to live off the riches of its manufacturing province. There were the Barcelona factory-owners fighting for independence from Madrid and the establishment of a capitalist state. (Generally speaking their enterprises were small and at a low level of development. When they were on a larger scale – as in the case of the banks or railways – they were compromised by being tied to political parties and so run in the interests of bureaucratic graft rather than efficiency and profit.) Lastly there was an inexperienced but violent proletariat, largely made up of recent peasant emigrants from the poverty of the south.

Madrid, for its own interests, encouraged the differences

between factory-owners and workers. The factory-owners, having no judiciary or state legal machinery with which to control their workers, had to dispense with legality and rule by direct force. The workers had to defend themselves against the representatives of Madrid (the army and the Church) and against the factory-owners. In such a situation, and with little political experience to help them, their aims were inevitably avenging and short-term – hence the continuing appeal of anarchism. Each group – one might almost say each century – fought it out with *pistoleros*, *agents provocateurs*, bombs, threats, tortures. All that in other modern cities was settled 'legally' – even if unjustly – by the machinery of the state, was settled privately in Barcelona in the dungeons of Montjuich Castle or by guerrilla warfare in the streets.

You may feel that what I have said about Spain has very little to do with Picasso's own experience. Yet only in fiction can we share another person's specific experiences. Outside fiction we have to generalize. I do not know and nobody can know all the incidents, all the images in his mind, all the thoughts that formed Picasso. But through some experience or another, or through a million experiences, he must have been profoundly influenced by the nature of the country and society he grew up in. I have tried to hint at a few of the fundamental truths about that society. From these alone we cannot deduce or prophesy the way that Picasso was to develop. After all, every Spaniard is different, and yet every Spaniard is Spanish. The most we can do is to use these truths to explain, in terms of Picasso's subjective experience, some of the later phenomena of his life and work: phenomena which otherwise might strike us as mysterious or arbitrary.

Yet, before we do this, there is another aspect of Picasso's early life which we must consider. The most obvious general fact about Picasso is that he is Spanish. The second most obvious fact is that he was a child prodigy – and has remained prodigious ever since.

Picasso could draw before he could speak. At the age of ten he could draw from plaster casts as well as any provincial art teacher. Picasso's father was a provincial art

teacher, and, before his son was fourteen, he gave him his own palette and brushes and swore that he would never paint again because his son had out-mastered him. When he was just fourteen the boy took the entrance examination to the senior department of the Barcelona Art School. Normally one month was allowed to complete the necessary drawings. Picasso finished them all in a day. When he was sixteen he was admitted with honours to the Royal Academy of Madrid and there were no more academic tests left for him to take. Whilst still a young adolescent he had already taken over the professional mantle of his father and exhausted the pedagogic possibilities of his country.

Child prodigies in the visual arts are much rarer than in music, and, in a certain sense, less true. The boy Mozart probably did play as finely as anybody else alive. Picasso at sixteen was *not* drawing as well as Degas. The difference is perhaps due to the fact that music is more self-contained than painting. The ear can develop independently: the eye can only develop as fast as one's understanding of the objects seen. Nevertheless, by the standards of the visual arts, Picasso was a remarkable child prodigy, was recognized as such, and therefore at a very early age found himself at the centre of a mystery.

Nobody has yet explained exactly how a child prodigy acquires or inherits his skill and knowledge. Is it that he is born with ready-made connexions in his mind, or is he simply born with a highly exaggerated susceptibility? In popular imagination the prodigy – whether child or adult – has always been credited with magical or supernatural powers: he is always thought of as an agent of some force outside himself. Paganini was believed to have been taught the violin by the devil.

To the prodigy himself his power also seems mysterious, because initially it comes to him without effort. It is not that he has to arrive somewhere; he is visited. Furthermore, at the beginning he does things without understanding why or the reasoning behind them. He obeys what is the equivalent of an instinctual desire. Perhaps the nearest we can get to imagining the extent of the mystery for him is to remember our own discovery of sex within ourselves. And even when we have become familiar with sex and have

learnt all the scientific explanations, we still tend to think of the force of it – whether we think in terms of the *id* or of reproductive instincts – as something outside ourselves, we still tend to project its force on to nature, to which we then gladly submit.

And so it is not surprising that most prodigies believe that they are a vehicle – that they are driven. Keats, the outstanding prodigy of English poetry, makes the point in a letter of 1818. First he distinguishes between two types of poet: the prodigious and the highly self-conscious, like Wordsworth. Of the character of the prodigy he says:

It is not itself – it has no self – it is everything and nothing – it has no character – it enjoys light and shade – it lives in gusto . . . a poet is the most unpoetical of anything in existence, because he has no identity; he is continually [informing] and filling some other body.

I myself have heard Yehudi Menuhin say words to very much the same effect. And Picasso, at the age of eighty-two, has just said: 'Painting is stronger than I am. It makes me do what it wants.'

The fact that Picasso was a child prodigy has influenced his attitude to art throughout his entire life. It is one of the reasons why he is so fascinated by his own creativity and accords it more value than what he creates. It is why he sees art as though it were part of nature.

Everyone wants to understand art. Why not try to understand the songs of a bird? Why does one love the night, flowers, everything around one, without trying to understand them? But in the case of painting people have to *understand*. If only they could realize above all that an artist works of necessity, that he himself is only a trifling bit of the world, and that no more importance should be attached to him than to plenty of other things which please us in the world, though we can't explain them.

This is partly a reasonable protest against all the pretentious intellectual constructions that have surrounded so much art in our time. But it is also a justification of the nature of his own genius as he sees it. He makes art like a bird sings. Understanding has nothing to do with it – indeed understanding is a hindrance, almost a threat.

I can hardly understand the importance given to the word research in modern painting. In my opinion to search means nothing in painting, to find is the thing.

This – perhaps the most quoted of all Picasso's remarks – has perplexed people ever since he made it in 1923. It is clearly untrue of modern painting in general. It was undeniably a spirit of research which inspired Cézanne, Seurat, Mondrian, Klee. Did Picasso say it simply to shock? Is it no more than another way of making the common-place observation that good intentions aren't enough? No. Like everything that Picasso says it is truer for him than seems likely. Picasso does not make paradoxes for their own sake – it is rather that his whole experience is para-doxical. He believes what he says because that is how it happened to him. He himself achieved art without searching. He found his own genius without looking for it. It happened apparently instantaneously, without any preparation on his part.

The several manners I have used in my art must not be considered as an evolution or as steps towards an unknown ideal of painting. All I have ever made was made for the present, and with the hope that it will always remain in the present. I have never taken into consideration the spirit of research. When I have found something to express, I have done it without thinking of the past or the future I have never made trials or experiments. Whenever I had some-thing to say, I have said it in the manner in which I have felt it ought to be said. Different motives inevitably require different methods of expression. This does not imply either evolution or progress, but an adaptation of the idea one wants to express and the means to express that idea.

Here is the secret of the extraordinary intensity of Picasso's vision. He has been able to see and imagine more suffering in a single horse's head than many artists have found in a whole crucifixion.

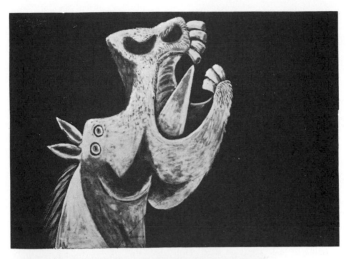

9 *Picasso.*
Head of a
Horse. 1937

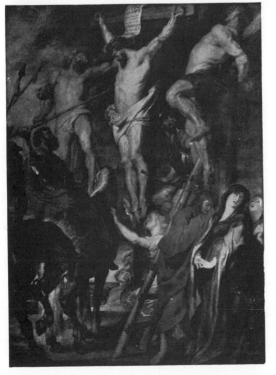

10 *Rubens.*
Christ
Crucified
Between Two
Thieves. 1620

He gives himself up utterly to the present idea or moment. The past, the future, plans, cause and effect – all are abandoned. He submits himself totally to the experience at hand. *All that he has done or achieved only counts in so far as it affects what he is at that moment of submission.* This is the way in which – ideally at least – Picasso works. And it is very close indeed to the way in which the prodigy submits to the force that plays through him.

Such is the positive result of the mystery at the centre of which Picasso found himself as a child. By respecting this mystery he has become the most expressive artist of our time. But there was also a negative result – which may have had as much to do with his childhood success as with the mystery. Picasso denies the power of reason. He denies the causal connexion between searching and finding. He denies that there is such a thing as development in art. He hates all theories and explanations. It would be understandable if he ignored all these intellectual considerations when it came to respecting and responding to the mystery of his own powers. But he goes further than this. He hates reasoning in general and despises the interchange of ideas.

There ought to be an absolute dictatorship, a dictatorship of painters, a dictatorship of one painter – to suppress all who have betrayed us, to suppress the cheaters, to suppress the tricks, to suppress mannerisms, to suppress charms, to suppress history, to suppress a heap of other things. But common sense always gets away with it. Above all let's have a revolution against that! The true dictator will always be conquered by the dictatorship of common sense – and perhaps not!

This is partly a joke. But nevertheless it reveals an uneasiness. He wants everything to be beyond argument. He wants to be beyond the reach of *evidence*.

They should put out the eyes of painters [he has said], as they do to goldfinches to make them sing better.

It is as though, in principle, he is frightened of learning. (It is perhaps relevant to note in passing that he is one of the very few modern painters who has never taught.) He is prepared to learn a new skill – pottery, lithography, welding – but as soon as he has learnt the technique, he needs to overthrow and disprove its laws. From this need

32

comes his marvellous power of improvisation and his wit, which respects nothing. Yet the need, however exhilarating the results, still betrays a certain defensiveness. I cannot explain this. I can only tentatively suggest a possibility. It seems to me odd that the story of Picasso's father giving his palette and brushes to his son, aged fourteen, and swearing never to paint again, has never been considered more seriously. If it is true, it is likely to have been a deeply formative experience for the young Picasso.

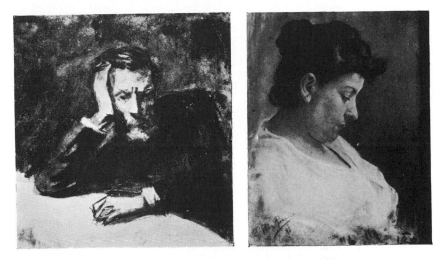

Is it likely that a boy will ever believe in progress step by step when at the age of puberty he is suddenly told by his father that he deserves to take his father's place and that his father is going to step down? Since this is what every boy wants to happen, is he not more likely to believe in magic? Yet at the same time, and again because he has wanted it to happen, is he not likely to feel guilty? The most obvious relief from his guilt is then to tell himself that his father's patience and slow development and experience do not, by the very nature of things, count for anything: that the only thing which can count is the mysterious power he feels within himself. But this relief can only be partial: he will remain frightened of explanations and of discussion with and between other people of the way he overthrew his father.

11 *Picasso.
Portrait of
Artist's
Father. 1895*
12 *Picasso.
Portrait of
Artist's
Mother. 1895*

33

We all know that Art is not truth. Art is a lie that makes us realize truth, at least the truth that is given us to understand. The artist must know the manner whereby to convince others of the truthfulness of his lies. If he only shows in his work that he has searched and re-searched for the way to put over lies, he would never accomplish anything.

The distinction between object and image is the natural starting point for all visual art which has emerged from magic and childhood. To exaggerate this distinction, as Picasso does here, until lie and truth are reversed, suggests that part of him still believes in magic and has remained fixed in his childhood. This seems the more convincing to me because conflicts between father and son are so often fought out in precisely these terms. The father accuses the boy of lying. The boy knows he is lying but believes that he is doing so for the sake of a more important and comprehensive truth that his father will never understand. The truth is the father's defence of his own authority. The lie is the son's way of escape from that authority. But if the lie is so obvious that the son can't defend it as the truth, nothing is accomplished and the father's authority is actually increased.

There may be a possible explanation here. But if you can accept neither it nor the psycho-analytic premises on which it is based, it is of little importance. The important point for our main argument is that for one reason or another, and as a corollary of his awareness of his prodigious gifts, Picasso has remained sceptical or suspicious of reasons, explanations, learning.

To emphasize this by contrast, I want to quote another painter. Juan Gris was of the same generation as Picasso and was also a Spaniard. He was a great painter – and his contribution to Cubism was as important as Picasso's – but he was in no way a prodigy. This is how he wrote in 1919:

I would like to continue the tradition of painting with plastic means while bringing to it a new aesthetic based on the intellect For some time I have been rather pleased with my own work, because I think that at last I am entering on a period of realization. What's more I've been able to test my progress: formerly when I started a picture I was satisfied at the beginning and dissatisfied at the end. Now the beginning

34

is always rotten and I loathe it, but the end, as a rule, is a pleasant surprise.*

Compare this with Picasso:

It would be very interesting to preserve photographically not the stages, but the metamorphoses of a picture. Possibly one might then discover the path followed by the brain in materializing a dream. But there is one very odd thing – to notice that basically a picture doesn't change, that the first vision remains almost intact, in spite of appearances.

Juan Gris has to travel and arrive – and believes in the intellect. Picasso is visited, denies progress – the picture does not go through stages but suffers metamorphoses – and thinks of the brain, not in terms of the intellect, but in terms of dream sequences. Gris's paintings develop from beginning to end. Picasso's paintings, however much they may appear to change, remain essentially what they were at their beginning.

Everything interesting in art happens right at the start. Once past the beginning you're already at the end.

Picasso is again talking here about a single painting, but what he says could apply to his whole life's work: a life's work made up not of stages, because that implies a desired destination, evolution, logical purpose, but made up of metamorphoses – sudden inexplicable transformations: a life's work which, despite appearances, has left unchanged and intact its first vision – that is to say the vision of the young Picasso in Spain.

The only period in which Picasso consistently developed as an artist was the period of Cubism between 1907 and 1914. And this period, as we shall see later, is the great exception in Picasso's life. Otherwise he has not developed. In whatever way one applied the coordinates, it would be impossible to make a graph with a steady ascending curve applicable to Picasso's career. Yet this would be possible in the case of almost every other great painter from Michelangelo to Braque. The only exceptions would be those painters who lost their vigour as they grew older. But this is not true of Picasso. So Picasso is unique. In the life

* See Letters of Juan Gris, edited and printed by Douglas Cooper.

35

work of no other artist is each group of works so independent
of those which have just gone before, or so irrelevant to
those which are to follow.

You can get some idea of this discontinuity in Picasso's
work by looking at three paintings – painted within two
years – and then comparing them with two typical Braques,
painted at the same time.

13
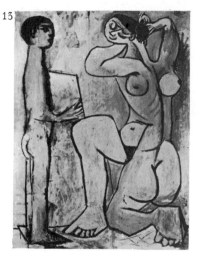

14
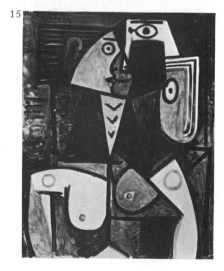

15

13 *Picasso.*
The Coiffure.
1954

14 *Picasso.*
Jacqueline
with Black
Scarf. 1954

15 *Picasso.*
Seated
Woman. 1955

Picasso's discontinuity is often cited as a proof of his vitality, of the amazing way in which he has stayed young. This begs the question of why he has stayed young and avoids all the tragic implications of his restlessness, but the observation is true enough. Picasso has stayed young. He has stayed young because he has not developed consistently. He has not developed consistently because (apart from the

37

brief Cubist interlude) he has not been open to explanations, suggestions, or arguments. Instead he has had to rely more and more exclusively upon the mystery of his own prodigious creativity.

I hope that I have now made it clear how Picasso's being a child prodigy has increased and prolonged the effect and influence of his early years. The power of his genius, in which he had to trust, became a barrier against outside influences, and even a barrier against any conscious plans of his own. He submitted to its will – in an eternal present. He stayed young.

But there is also another reason why the prodigious nature of his gifts ties him closely to Spain. The mystery of his powers is of a kind that Spain recognizes. In Spain Picasso's spirit – as opposed to his art – would become immediately comprehensible.

Lorca, who was born near Granada eight years after Picasso, wrote an essay on the subject of the creatively possessed. It is called 'Theory and Function of the *Duende*'.* The *duende* is a kind of undiabolic demon. Lorca quotes an Andalusian singer as saying 'All that has dark sounds has *duende*'. Then Lorca goes on:

These dark sounds are the mystery, the roots thrusting into the fertile loam known to all of us, ignored by all of us, but from which we get what is real in art.

As Lorca goes on defining the *duende*, he hints at why historically the concept is peculiarly Spanish. He makes a distinction between the *duende* and a muse, and the *duende* and an angel. For him a muse represents the spirit of classicism leading on to enlightenment – as, say, in Poussin. An angel represents lucidity leading to Renaissance humanism – as, say, in Antonello da Messina. Both, he claims, are despised in Spain, because neither challenges death.

The *duende*, on the other hand, does not appear if it sees no possibility of death . . . in idea, in sound, or in gesture, the *duende* likes a straight fight with the creator on the edge of the well. While angel and muse are content with violin or measured rhythm, the *duende* wounds, and in the healing of this wound which never closes is the prodigious, the original in the work of man.

* See *Lorca*, Penguin Books, 1960.

The *duende* is born of hope:

The appearance of the *duende* always presupposes a radical change of all forms based on old structures. It gives a sensation of freshness wholly unknown, having the quality of a newly created rose, of miracle, and produces in the end an almost religious enthusiasm.

Yet it has to lead to fatality. Its most spectacular appearance is in the bullring, where death is certain.

In every country death has finality. It arrives and blinds are drawn. Not in Spain. In Spain they are lifted. Many Spaniards live between walls until the day they die, when they are taken out to the sun. A dead person in Spain is more alive when dead than is the case anywhere else . . .

The *duende* is the inspired cry of defiance of those on the rack. It is the impatience to have done, to break free from all material beginnings which appear never to develop: it is the attempt to transcend those beginnings by abandoning everything to the moment. And in certain circumstances the *duende* guarantees art.

At that moment La Niña de los Peines got up like a woman possessed, broken as a medieval mourner, drank without pause a large glass of *cazalla*, a fire-water brandy, and sat down to sing without voice, breathless, without subtlety, her throat burning, but . . . with *duende*. She succeeded in getting rid of the scaffolding of the song, to make way for a furious and fiery *duende*, companion of sand-laden winds, that made those who were listening tear their clothes rhythmically, like Caribbean Negroes clustered before the image of St Barbara.

La Niña de los Peines had to tear her voice, because she knew that she was being listened to by an *élite* not asking for forms but for the marrow of forms, for music exalted into purest essence. She had to impoverish her skills and aids; that is, she had to drive away her muse and remain alone so that the *duende* might come and join in a hand-to-hand fight. And how she sang!

In 1904 Picasso arrived to settle in Paris. What did he notice? How did it strike him? Or, more important, what did the impingement of all that was now around him, make him feel that he was? All definitions involve an investigation of relationships. How did Picasso have to define

39

himself, his inner self possessed by the *duende*, in relation to Paris? What did Europe make Picasso become?

Ortega y Gasset is the last of the classically reactionary thinkers; he cannot, like all the dons who still apologize for capitalism and who pretend that imperialism doesn't exist, be dismissed as an opportunist. He has been preserved in Spain as in amber, and he is acute and imaginative enough to be obsessed by the historical situation in which he finds himself. All his books are about the historical rack. I think of him because he invented a phrase which is so apt for Picasso. He is generalizing about the modern European masses. On to them he projects all his aristocratic fears of the underprivileged and uneducated. He uses the word primitive in a pejorative sense. But in the case of a truly imaginative writer, images can transcend conclusions. This is what he writes:

The European who is beginning to predominate . . . must then be, in relation to the complex civilization into which he has been born, a primitive man, a barbarian appearing on the stage through the trap-door, a vertical invader.*

Picasso was a vertical invader. He came up from Spain through the trap-door of Barcelona on to the stage of Europe. At first he was repulsed. Quite quickly he gained a bridgehead. Finally he became a conqueror. But always, I am convinced, he has remained conscious of being a vertical invader, always he has subjected what he has seen around him to a comparison with what he brought with him from his own country, from the past.

I do not want to suggest that Picasso is naïve, that he was a kind of sublime but helpless farm boy like the Russian poet Yessenin (who also was a kind of prodigy). Picasso was shrewd and even cunning. He soon had the measure of the society he found himself in. And in his case there is less evidence than with any of his contemporaries, who suffered in the same way, that he was fundamentally changed or damaged by the first years of poverty and neglect. The fact that he was a vertical invader from the past was not, in any obvious way, a handicap, and it soon appeared to be an

* See *Revolt of the Masses*, by Ortega y Gasset (Allen & Unwin, 1932).

40

advantage. What it gave him were special standards with which to criticize what he saw.

Picasso never doubted that he had to stay in Paris. He needed Paris. He needed the example of other painters, the friends he could find there, the chance of success which it offered, its sense of modernity, its European scale. He had no illusions about Spain. He recognized that as a painter in Spain he had to deal with the middle classes and he was aware of their imprisoning provincialism. He was fully aware that Paris represented progress, and that he had his own contribution to make to that progress.

Yet at the same time this progress, as he found it working itself out in reality, horrified him. It took away with one hand what it gave with the other. Poverty is not surprising to any Spaniard. But the poverty Picasso witnessed in Paris was of a different kind. In the Paris self-portrait of 1901

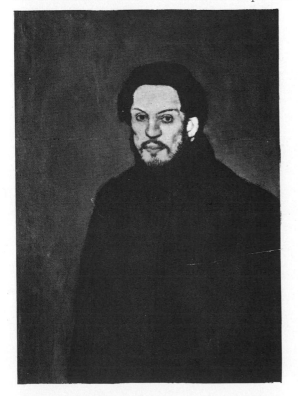

18 *Picasso.*
Self-Portrait.
1901

41

we see the face of a man who not only is cold and hasn't eaten much, but who is also silent and to whom nobody talks. Nor is this loneliness just a question of being a foreigner. It is fundamental to the poverty of outcasts in a modern city. It is the subjective feeling in the victim that corresponds exactly to the objective and absolute ruthlessness that surrounds him. This is not poverty as a result of primitive conditions. This is poverty as the result of man-made laws: poverty which, legally accepted, must be dismissed from the mind as unworthy of any consideration.*
Many peasants in Andalusia must have been hungrier than the couple at table in the etching of *The Frugal Meal*.

* For further analysis of such poverty and loneliness, see *Vagrancy*, by Philip O'Connor (Penguin Books, 1963).

19 *Picasso.
The Frugal
Meal. 1904*

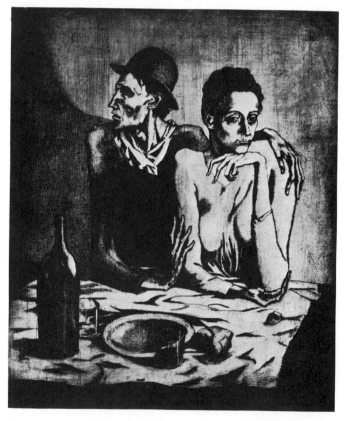

But no couple would have been so demoralized, no couple would have felt themselves to be so worthless. Here is an extract from an anarchist pamphlet published in Andalusia at about the same time as this etching was made in Paris:

On this planet there exist infinite accumulations of riches which, without any monopoly, are enough to assure the happiness of all human beings. We all of us have the right to well-being, and when Anarchy comes in, we shall every one of us take from the common store whatever we need: men, without distinction, will be happy: love will be the only law in social relations. *

The couple at the table have left such naïve hopes far behind. They would laugh outright at such innocence. But by this advance (for the anarchist hopes *are* unrealistic) what have they gained? What has their wider knowledge and experience brought them? A profound contempt for reality and hope, for others, and for themselves. Their only value, as Picasso sees them according to the logic of the European city, is that they represent the antithesis of the well-fed. They do not claim any rights. They scarcely claim humanity. They claim only disease with which to shame health, vulgarized and monopolized by the bourgeoisie. It is a terrible advance.

This is not of course the only logic of a European city. Picasso's view is one-sided, and this helps to explain the sentimentality of much of his work at this time – such exaggerated hopelessness borders on self-pity. (It is also why, much later, paintings of this period became so popular with the rich. The rich like to think only of the lonely poor: it makes their own loneliness seem less abnormal: and it makes the spectre of the organized, collective poor seem less possible.)

Yet Picasso's attitude is understandable enough. His politics were very simple. It was among the outcasts, the *Lumpenproletariat*, that he lived. Their misery was of a kind he had never before imagined. Probably, he was also suffering from venereal disease and was obsessed by it. In many of his pictures at this time he dealt with the theme of blindness. Critics point out that he must have seen many

* Quoted in *The Spanish Labyrinth*, by Gerald Brenan (Cambridge University Press, 1943).

43

blind beggars in Spain, but I believe the significance of the subject was deeper and more personal: Picasso feared blindness as a result of his disease. He imagined this disease destroying the very centre of him, and this subjective vision corresponded with the real examples of socially induced self-destruction which he saw all around him.

Quite quickly – and it may have been connected with an improvement in his health – Picasso became more defiant. He still painted outcasts and still identified himself with them, but they were no longer hopeless victims. They now had skills and a tradition of their own. They became acrobats or clowns and their way of life was nomadic and independent.

20 *Picasso. Clown with a Glass (self-portrait). 1905*

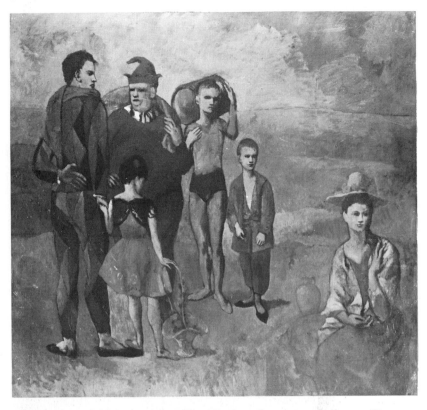

It becomes highly questionable whether these men and women would ever agree to become members of modern European society. They may be underfed and scantily dressed, but they have kept their distance and self-respect, and the grace of their skills is a token of a purity of spirit unattainable in a modern city. They are primitives in the sense that they are nearer to nature. They may be sad, but they know nothing of *legalized* suffering.

As if to emphasize this point of their nearness to nature, of their familiarity with natural as opposed to man-made law, Picasso often includes animals in these paintings, but animals with whom the figures have a special understanding. A boy leads a horse. Others ride horses bare-back. A dog nuzzles against a leg. A goat follows a girl. An ape sits beside a woman like a brother to the child on her lap.

21 *Picasso. Family of Saltimban- ques. 1905*

45

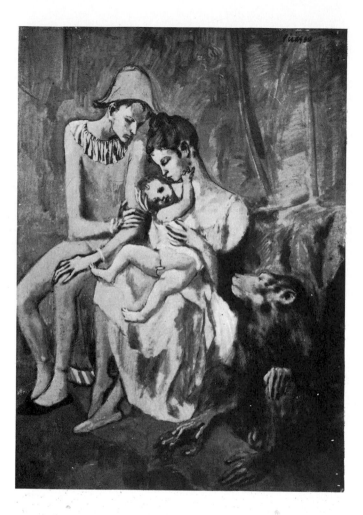

22 Picasso.
Acrobat's
Family with
Ape. 1905

Perhaps I should make it clear that I am not now concerned with judging these pictures – though personally I find them over-nostalgic and mannered. Nor need we be concerned with the stylistic problems which most writers about Picasso set themselves. Why during the Blue Period did Picasso paint in blue? And why did he paint in pink in 1906? The answers may be interesting, but there is a grave danger of not seeing the wood for the trees.

If we are concerned with the spirit of Picasso which appears to dominate all else, then the following is what is essential for our purpose: Picasso recognized that he had to come to Paris because he knew that he had no professional future in Spain; in Paris he came face to face with the misery of a modern European city – a misery which combines brute suffering with delirium; he reacted against this by idealizing simpler, more primitive ways of life.

So far, it might seem that his coming to Paris was of doubtful value. Might it not have been more logical to reject the whole idea of being a *professional* painter and leave Europe, as Gauguin had done fifteen years earlier, for the South Seas?

The value of Picasso being in Paris is proved by what happened from 1907 onwards. Earlier, he had already begun to make friends with French painters and poets – particularly with Max Jacob and Guillaume Apollinaire. In 1907 he met Braque. What happened from then onwards is the history of Cubism. Cubism as a style was created by painters, but its spirit and confidence were maintained by poets. From 1907 to 1914 Cubism transformed Picasso – that is to say Paris and Europe transformed him. Perhaps transformed is too strong a word: Cubism gave Picasso the possibility of going outside himself, of giving his nostalgia the means to become a passionate plea, not for the past, but for the future. And this is true despite the fact that Picasso was one of the creators of Cubism. I have already said that Picasso's Cubist period was the great exception of his life. If we are to understand how this 'exception' came about, and how Cubism transformed Picasso, we must now examine the historical basis of the Cubist movement.

It is almost impossible to exaggerate the importance of Cubism. It was a revolution in the visual arts as great as

that which took place in the early Renaissance. Its effects on later art, on the film, and on architecture are already so numerous that we hardly notice them.

Let us compare a Cubist painting of a chair with a Fra Angelico altar-piece.

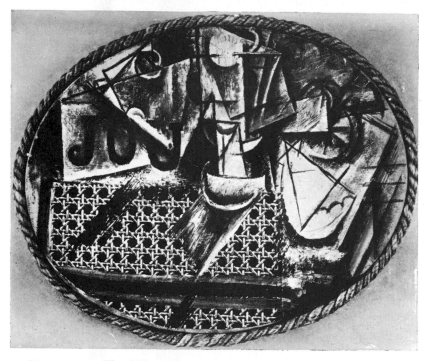

23 Picasso.
Still-life
with Chair-
caning. 1912

The differences may at first be startling, but there are also similarities. In both paintings there is a delight in clarity. (Not necessarily a clarity of meaning, but a clarity of the forms.) Nothing comes between you and the objects depicted – least of all the artist's temperament: subjectivity is at a minimum. In both paintings the substance and texture of the objects is freshly emphasized – as though everything was just newly made. In both paintings the space in which the objects exist is clearly very much part of the artist's concern, although the laws of that space are very different: in the Fra Angelico the space is like that of a stage-set

48

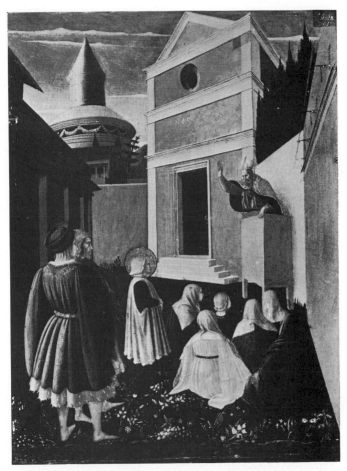

seen from the auditorium; in the Picasso the space is
more like that of a landscape seen from the air. Lastly, in
both paintings there is a simplicity and lightness, a lack of
pretentiousness, which suggests an almost blithe confidence.
One might think that one could find the same qualities in
paintings from any period, but this is not the case. There
is nothing comparable in the five centuries between.

The similarities between these two paintings are the
result of a similar sense of disovery, of *newness*, which
affects the world seen and the artist's view of himself.
There is scarcely any distinction, because both seem so

24 *Fra
Angelico.
The Vocation
of St Nicholas
(detail).* 1437

49

25 Picasso.
The Fruit-
dish. 1912

new, between what is personal and what is impersonal.

Is *The Fruit-dish* an exercise in a new way of seeing, a challenge to the whole history of art to date? Or is it just a view of the corner table in the café which the artist always goes to?

Such a sense of newness has nothing to do with the artist's own originality. It has to do with the time in which he lives. More specifically it has to do with *the possibilities suggested*, with an awareness of promise – in art, life, science, philosophy, technology. During the early Renaissance the promise of the new humanism, the newly prosperous and forward-looking Italian city-states, the new man-centred science, lasted for about half a century – approximately from 1420 to 1480. For the Cubists the promise of the modern world lasted about seven years – from 1907 to 1914.

What was this promise? What were the possibilities suggested? Let us first consider the question from the point of view of art. Then, later, we will take a broader, more general view.

I have referred to Cubism as a revolution in art. It did far more than extend the language of art as, say, Impressionism did. And it was far more than a stylistic revolt against what had preceded it. Cubism changed the nature of the relationships between the painted image and reality, and by doing this it placed man in a position which he had never been in before.

Mankind always takes up only such problems as it can solve; since, looking at the matter more closely, we will always find that the problem itself arises only when the material conditions necessary for its solution already exist or are at least in the process of formation.

This famous quotation from Marx concerning social revolution applies also to art. The preparations for a revolution are always gradual. (The flaw in the Fabians' view of 'the inevitability of gradualness' is that they expect the preparations to go on for ever and thus to cease to be preparations and to take the place of the revolution itself.)

The preparations for the revolution of Cubism were begun in the nineteenth century by two artists: Courbet and Cézanne. The importance of Cézanne for the Cubists has been stressed so often that it has become a commonplace. As for Courbet, Apollinaire in *Les Peintres Cubistes* (which

51

was the first full-length communiqué issued by the Cubists) says quite simply: 'Courbet is the father of the new painters.'

Both Courbet and Cézanne changed the emphasis of the painter's approach to nature: Courbet by his materialism, Cézanne by his dialectical view of the process of looking at nature.

No painter before Courbet was ever able to emphasize so uncompromisingly the density and weight of what he was painting. You can see it in the way he painted an apple or a wave, or in the way he painted the heavy languor and creased dresses of two girls lying by the Seine.

26 Courbet. Les Demoiselles des bords de la Seine. 1856

He was the heroic St Thomas of painting – in so far as he believed in nothing which he could not touch and judge with his hand. Painters had come to rely on pictorial conventions – light and shade for solidity, perspective for space – to give the illusion of reality, and then to give self-indulgent fantasies the semblance of reality. Courbet, whilst still using paint on canvas, wanted to go beyond such conventions and find the equivalent of the physical sensation of the material objects portrayed: their weight, their

52

temperature, their texture. What perspective towards the horizon had once meant to Poussin, the *force of gravity* meant to Courbet.

27 *Courbet.*
The Pond.
1860s

28 *Poussin.*
Orpheus and
Eurydice.
1650

Cézanne was very different in both temperament and background; whereas Courbet's art was based on conviction – if once he could be given tangible proof – Cézanne's was based on perpetual doubt. His doubts arose out of conflict raging within him. On one hand he wanted to create an ordered, harmonious vision of the world like Poussin; on the other hand he knew, with the help of Impressionism and on the scrupulously examined evidence of his own eyes, that everything seen was relative, and that no single painted view of anything could do justice to the experience of it in reality.

He observed that if he moved his head a little to the right he saw a different aspect of what was in front of him from what he would see if he moved his head a little to the left. Every child discovers this by lying in bed and closing each eye alternately. Every painter must have observed it since painters first drew from nature. The difference was that Cézanne thought it mattered.

The Impressionists had shown how appearances change with the light. Degas had shown how appearances are changed by rapid movement. Gauguin and the Symbolists were making a virtue out of subjective distortion.

It is well for young men to have a model [Gauguin said], but let them draw the curtain over it while they are painting. It is better to paint from memory, for thus your work will be your own.

Cézanne was surrounded by those who were disconnecting and making art more and more fragmentary. He resented this. He longed for precision and synthesis: a longing made the more intense because it was partly a defence against the violence of his own emotional nature.

It was this resentment which first made him think that the changes he observed when he moved his head mattered. He was haunted by the evidence and then by his longing for order, one after the other, as though when he shut one eye he saw one ghost, and when he shut the other, he saw the second. He had either to go mad or break through. He broke through in the only way he could – with a dialectical solution which destroyed the opposition between the two demands and admitted them both.

Cézanne began to put down on the canvas the variations of what he saw as he slightly changed his view-point. One

tree becomes several possible trees. In his later works he also left a large area of the canvas or paper blank. This device served several purposes, but the most important is seldom mentioned: the blank white spaces give the eye a chance to add imaginatively to the variations already recorded; they are like a silence demanded so that you can hear the echoes.

The order in a painting like *Trees by the Water* has been established *between* the possibilities suggested by the different view-points. A new kind of certainty has been called into being – a certainty based on the acceptance of doubt. Nature in a picture is no longer something laid out in front of the spectator for him to examine. It now includes him and the evidence of his senses and his constantly changing relationships to what he is seeing. Before Cézanne, every painting was to some extent like a view seen through a window. Courbet had tried to open the window and climb out. Cézanne broke the glass. The room became part of the landscape, the viewer part of the view.

This then was the revolutionary inheritance that the nineteenth century bequeathed to the twentieth: the materialism of Courbet and the dialectic of Cézanne. The task was to combine the two. Followed up separately, each

would lead to a cul-de-sac. Courbet's materialism would become mechanical; the force of gravity, which gave such dignity to his subjects, would become oppressive and literal. Cézanne's dialectic would become more and more disembodied and its harmony would be obtained at the price of physical indifference.

Today both examples *are* followed up separately. Most painting in the world now is either banally and mechanically naturalistic or else abstract. But for a few years, from 1907 onwards, the two were combined. Despite the ignorance and philistinism of Moscow in its Stalinist and post-Stalinist pronouncements about painting, and despite the fact that none of the artists concerned were in any way marxists, it is both possible and logical to define Cubism during those years as the only example of dialectical materialism in painting.

However, to pursue this point further now would take us too far from our immediate purpose. What we need to understand is the promise originally offered by Cubism. What could its painters hope to achieve?

They hoped to achieve a truly modern art, an art that belonged to the new century. Apollinaire expressed this many times:

. . . we who are constantly fighting along the frontiers of the infinite and of the future.

This sense of modernity was expressed in Cubist paintings in several different ways.

1. By the choice of subject. The subjects were taken from everyday life in a modern city. But, unlike the Impressionists, the Cubists seldom painted natural ' sights ' – the Seine, parks, gardens. The one monument that appealed to them was the Eiffel Tower. They were interested in constructions and in the man-made. Mostly they painted what was to hand – in the literal sense of the term: café tables, cheap chairs, coffee cups, newspapers, carafes, soda-syphons, ash-trays, wash-stands, letters. In their choice of objects they emphasized the ordinariness of their possessions. This ordinariness was of a new kind, because it was the result of cheap mass-production. It is true that sometimes, (because Braque liked music) they included violins and guitars, but they were treated with no more – and no less – deference than the other objects; and, after all, they also

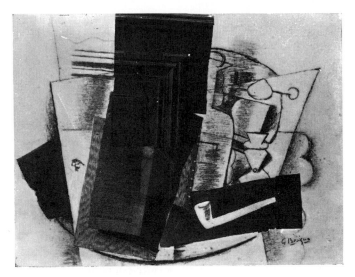

30 *Braque.*
Bottle, Glass,
and Pipe.
1913

were man-made. It was as though the Cubists wanted to celebrate a value never before admitted in art: the value of the manufactured.

2. By the materials used. Apart from paper and ink, canvas and paint, the Cubists introduced new techniques and materials. They used stencils for making letters and numbers, they stuck paper, oil-cloth, cardboard, tin, on to their pictures. They imitated house-painters (Braque's father was a house-painter) by using a 'comb' to give a painted illusion of wood-graining, they mixed sand and sawdust with their pigment to give it a special texture, they combined techniques – using, for example, pencil with oil-paint. Such experiments were in themselves modern for two reasons. They challenged the whole bourgeois concept of art as something precious, valuable, and to be prized like jewellery. (That these same works, now insured like jewellery, hang today in bourgeois homes beside Boudins and Ingres drawings is one of the ironies of art history.) They were made from what you could find in any hardware store. The challenge in this was the equivalent of putting a printed pamphlet beside a medieval psalter and demanding: which do you choose – beautiful illumination or literacy? The second way in which these experiments were modern lay in their claim for a new freedom for the artist. The

57

artist now had the right to use *any* means: according to the demands of his vision, no longer according to the demands of his professional etiquette.

3. By the way of seeing. This is far more difficult to summarize briefly. The Cubist vision is as complex philosophically as the subjects and materials were deliberately modest. The painters were at great pains to establish the physical presence of what they were representing. And it is here that they are the heirs of Courbet. In the still-lifes this reality of the physical presence is often expressed by the materials used. A newspaper is represented by an actual piece of newsprint. The panelling of a wooden drawer in a table is represented by a piece of imitation wooden-panelled wallpaper. Like Courbet, they hated the conventions that had forgotten their origins: the oil paint in love with itself. Yet they had to use conventions. So they preferred to use the simplest ones which our eyes can still accept innocently: ones which can lead immediately to a vivid awareness of different physical surfaces – wood, paper, stone, metal.

In their figure paintings they approached the problem differently. It was not the presence of the figure as a person of flesh and blood which they now stressed: but the physical complexity of the structure of that figure. At first it may be

31 *Picasso.*
Portrait of
Monsieur
Kahnweiler.
1910

32 *Gris.*
Portrait of
Picasso.
1911–12

31

32

58

quite difficult to find the person; and, when found, he or she may have little connexion with the sensuous experience of a body. But the structural arrangement which the body inhabits is made as tangible and precise as the architecture of a town. There is no ambiguity in, as it were, the alphabet used: it is as clear as a printed script; the ambiguity is only in the meaning of some of the words.

This austerity of approach in relation to the figure was at least partly the result of a reaction against excessive talk of the spiritual and soulful. By reducing the body to an organization, comparable with that of a city, they assert the unmetaphysical character of man. They infer (though none of them would have put it in these words) that 'consciousness is a property of highly organized matter'.

The system of organization which the Cubists used leads us back to Cézanne, their other precursor. Cézanne raised and allowed the question of there being simultaneous viewpoints, and thereby destroyed for ever in art the possibility of a static view of nature. (Constable's view, for all its bustling clouds, was nevertheless static.) The Cubists went further. They found the means of making the forms of all objects similar. They achieved this by reducing all forms to a combination of cubes, cylinders, and – later – facets and planes with sharply defined edges. The purpose of this simplification was to be able to construct the most complex view of reality ever attempted in the visual arts. The simplification was very far from being for simplification's sake. If everything was rendered in the same terms (whether a hand, a violin, or a window) it became possible to paint the interactions between them; their elements became interchangeable. Furthermore, the space in which they all existed could also be rendered in the same terms – but in obverse. (Where the surface of an object was concave, the surface of the space was convex.)

The Cubists created a system by which they could reveal visually the interlocking of phenomena. And thus they created the possibility in art of revealing *processes* instead of static states of being. Cubism is an art entirely concerned with interaction: the interaction between different aspects: the interaction between structure and movement; the interaction between solids and the space around them; the interaction between the unambiguous signs made on

59

the surface of the picture and the changing reality which they stand in for. It is an art of dynamic liberation from all static categories.

All is possible [wrote André Salmon, a Cubist poet], everything is realizable everywhere and with everything.

It is impossible to explain in terms of social and economic history why Cubism began in 1907 and not 1903 or 1910. Sociological explanations of particular works of art or movements in art can never be as precise as that. Indeed they can never be full explanations. They are rather like circumstantial evidence. They can strengthen a case – but should not open one: sometimes they can also destroy a case which has been wrongly opened.

We have already noted the contrast between a feudal Spain and a capitalist Europe: a contrast between the terrible equilibrium of the rack and the ceaseless activity of competition. Spain remained the same. Europe was changing.

By 1900 the actual nature of capitalism had changed. Competition still existed, but it was no longer free and open. The era of monopoly had begun.

In 1912 about one-third of the total national wealth of the United States was owned or controlled by two trusts – Rockefeller and Morgan. (Later the division became less dramatic but no less characteristic of monopoly.) In Germany in 1907 a few large enterprises, representing less than one-hundredth of the total number of German industrial firms, were using more than three quarters of all the steam and electric power available.

The transformation was the result of the scale of production demanded by the new means of production. Steel, electricity, and the new chemical industries were beginning to transform not only the face of the world but also the economic system which had encouraged the discovery of their uses.

Parallel with this development there had been a period of rapid colonial expansion. Between 1884 and 1900 the European powers added one hundred and fifty million subjects and ten million square miles to their empires. By 1900 they had reached the stage where, for the first time,

there was nothing left to claim – except by claiming from one another. The whole world was owned.

Today we cannot forget or ignore what all this was leading to. We see the First World War, Nazism, the Second World War, the struggles for independence from imperialism, the millions of dead: starved, burnt or dismembered. We can also see the increasing anonymity of life as the scale grew larger and larger: the anonymity of death by the electric chair (first authorized in 1888), of the skyscraper, of government decisions, of the threat of nuclear war. Kafka, whose formative years were 1900 to 1914, was the prophet of this anonymity. Other artists of the same period – Munch and the German Expressionists – sensed the same thing, but only Kafka understood the full horror of the new bargain: the bargain by which in exchange for sustenance a man forgoes the right to have his existence noticed. No god invented by man has ever had the power to exact such punishment.

Yet this is only one half of the truth: the enormous and most dramatic truth in whose unfolding and realization we, born in the first half of the twentieth century, are participating. Imperialism and monopoly capitalism also represented a promise. By 1900 or 1905 the scale of both our fears and hopes were fixed, though nobody at the time fully realized it.

Monopoly capitalism was the highest, most developed form of economic organization yet achieved by man. It involved planning on an unprecedented scale, and it suggested the possibility of treating the whole world as a single unit. It brought men to the point where they could actually see the means of creating a world of material equality. This point is the opposite pole from where the old anarchist stands looking down at Malaga.

Lenin was the first to see the new developments in this light. In 1916 in *Imperialism: The Highest Stage of Capitalism* he wrote as follows:

When a big enterprise assumes gigantic proportions, and, on the basis of exact computation of mass data, organizes according to plan the supply of primary raw materials to the extent of two thirds or three quarters of all that is necessary for tens of millions of people; when the raw materials are transported to the most suitable place of production, sometimes

hundreds or thousands of miles away, in a systematic and organized manner; when a single centre directs all the successive stages of work right up to the manufacture of numerous varieties of finished articles; when these products are distributed according to a single plan among tens and hundreds of millions of consumers (as in the case of the distribution of oil in America and Germany by the American 'oil trust') – then it becomes evident that we have socialization of production In spite of themselves, the capitalists are dragged, as it were, into a new social order, a transitional social order from complete free competition to complete socialization. . . . Production becomes social but appropriation remains private.

As a result of the First World War, there occurred the first successful socialist revolution; after the Second World War a third of the world became socialist. I have no wish to be over-schematic or ever to forget the suffering and sacrifices that the creation of modern socialism has involved, but it is undeniable that today the hopes of the overwhelming majority of the world are contained within some form of modern socialism, and that imperialism and capitalism are so much on the defensive that their apologists have to deny their continued existence. For all this the stage was set between 1900 and 1914.

The Cubists knew nothing of the historic necessities and alternatives that were going to reveal themselves. They were not politically concerned. They were not clear even amongst themselves of the meaning of 'the future' in which they believed. Perhaps the one item they could have agreed upon was that in the future their Cubist paintings would not look incongruous if hung in the Louvre. They sensed that a qualitative change was taking place and that the bourgeois – whom they hated for his manners and tastes – would soon be outdated: but they did not know why or how. Their sense of change was largely the result of the impact of new inventions and new material possibilities.

Mass production of clothes, shoes, china, paper, food, bicycles had begun in the eighties and nineties. The whole tempo and scale of city life was being altered. The rate of change was acquiring the speed of a machine – and this could be seen in the streets, the shops, the new newspapers.

The Eiffel Tower, which was to remain the highest

structure in the world until after 1918 (it is one thousand
feet high) and which could only have been built with
modern steel, became a symbol of the new possibilities.
It had been built for the 1889 International Exhibition,
where there were also electrically illuminated fountains
which had persuaded people that electricity was the key to a
fantastic future. (It was from the nineties but particularly
from 1900 onwards that electrical power began to be applied

so as to affect people's lives. This was largely the result of solving the problems of transmitting power over greater distances by the invention of the alternating current and the transformer.) Apollinaire ended a poem he wrote in 1903 as follows:

> Paris evenings drunk with gin
> Aflare with electricity
> Trams with green dorsal lights
> Turn machine madness into music
> Along the sections of their rails.
>
> Cafés puffed out with smoke
> Propose their love of gypsies
> And their soda syphons with catarrh
> And their waiters dressed in loincloths
> To you to you whom I have loved so much.

The Paris Exhibition of 1900 was even more dramatic. There were thirty-nine million visitors. (The organizers had actually expected sixty-five million!) There were contributions from everywhere. There was Esperanto – an international language to further the unity and accessibility of the world. There were motor-cars. There was chromium. There was aluminium. There were synthetic textiles. There was wireless.

At the beginning of the century there were only 3,000 motor vehicles in France. In 1907 there were 30,000. By 1913 France was producing 45,000 a year.

The Wright brothers began working on aeroplanes in 1900. Their first successful flight, lasting fifty-nine seconds, was in 1903. In 1906 Dumont in France made a short flight. In 1908 Wright flew for ninety-one minutes. In 1909 Bleriot crossed the channel:

The Cubists' belief in progress was by no means complacent. They saw the new products, the new inventions, the new forms of energy, as weapons with which to demolish the old order. Yet at the same time their interest was profound and not simply declamatory. In this they differed fundamentally from the Futurists. The Futurists saw the machine as a savage god with which they identified themselves. Ideologically they were precursors of fascism:

34 *Roger de la Fresnaye. Conquest of the Air. 1913*

35 *Carlo
Carra. The
Funeral of
the Anarchist
Galli. 1911*

artistically they produced a vulgar form of animated naturalism, which was itself only a gloss on what had already been done in films.

The Cubists felt their way, picture by picture, towards a new synthesis which, in terms of painting, was the philosophical equivalent of the revolution that was taking place in scientific thinking: a revolution which was also dependent on the new materials and the new means of production.

The reason why we are on a higher imaginative level [wrote A. N. Whitehead in 1925*] is not because we have finer imaginations, but because we have better instruments. In science the most important thing that has happened during the last forty years is the advance in instrumental design. This advance is partly due to a few men of genius such as Michelson and the German opticians. It is also due to the progress of technological processes of manufacture, particularly in the region of metallurgy.

In 1901 Max Planck published the Quantum Theory. In 1905 Einstein published the Special Theory of Relativity. In 1910 Rutherford discovered the atomic nucleus. By 1905 Newtonian physics – with its mechanistic and some-

* In *An Enquiry Concerning the Principles of Natural Knowledge* (Cambridge University Press, 1925).

66

what utilitarian emphasis – was superseded. It had come into being with the first promise of the bourgeois state. It had achieved everything that was to be seen in the International Exhibition of 1900. It was superseded as the development of the same bourgeois state reached a point of critical transformation.

The emphasis of modern physics, and indeed all modern science, is on function and process. It denies the fixed state. It substitutes the notion of behaviour for the notion of substance.

Already in the nineteenth century Darwin and Marx had put forward hypotheses which questioned – with facts rather than abstract arguments – the Cartesian division between body and soul. By doing this they also challenged the other fixed categories into which reality had been separated. They saw that such categories had become prisons for the mind, because they prevented people seeing the constant action and interaction between the categories. They found that what distinguished a particular event was always the result of the relationship between that event and other events. If, for a moment, we use the word *space* purely diagrammatically, we can say that they realized that it was in the space *between* phenomena that one would discover their explanation: the space, for example, *between* ape and man: the space *between* the economic structure of a society and the feelings of its members.

This involved a new mode of thinking. Understanding became a question of considering all that was *interjacent*. The challenge of this new mode of thought was foreseen by Hegel. Later it inspired Marx to create the system of dialectical materialism. Gradually it affected all branches of research. Its first tentative formulation in the natural sciences was in the study of electricity. Faraday, wrestling with the problem – as defined in traditional terms – of 'action at a distance', invented the concept of a field of force, the electro-magnetic field. Later, in the 1870s, Maxwell defined such a field mathematically.

Yet the full implications of the concept of the field – this most basic of modern concepts – could not be understood until the Special Theory of Relativity. Only then was the field proved to be an independent reality.

The conclusions eventually drawn from the Quantum

Theory go even further in showing the impossibility of isolating a single event. They state that our relationship to that event is always an additional and possibly distorting factor.

Natural science [wrote Heisenberg] does not simply describe and explain nature; it is part of the interplay between nature and ourselves; it describes nature as exposed to our method of questioning.*

Physicists are always at great pains to point out that Quantum mechanics only become significant on an atomic, extremely small scale. They are right to do this, because the whole paradox of the Quantum Theory depends upon the fact that the experiments are planned – and have to be – according to the large-scale but approximate calculations of classical physics, whereas the results of these experiments have to be interpreted according to Quantum mechanics. Yet, in another sense, it is unimportant that the theory only becomes significant on a certain scale. It was the macrocosmic view of the solar system which helped to liberate man from his belief in a God-controlled world. It is the microcosmic view of the atom and its nucleus which is now helping to liberate him from the frustrating and static utilitarianism of his own system of categorizing: a system which in itself is a reflection of the essential opportunism of the capitalist phase of history. Opportunism implies, by definition, a blindness to underlying connexions. The planets brought us to the threshold of self-consciousness, the atom is bringing us to the threshold of a consciousness of the indivisibility of all reality. This is what is important, regardless of the scale involved.

Quantum mechanics demonstrate that, on an atomic scale, it is impossible to distinguish, even in definition, between a wave and a particle. This led Niels Bohr to his theory of complementarity, whereby both statements, apparently contradictory, might at any moment be equally true. It led Heisenberg to his Uncertainty Principle, which states that, on the same scale, it is impossible to divide the potential from the actual. Further discoveries may change these theories. But what the processes themselves

* This quotation comes from Heisenberg's *Physics and Philosophy* (Allen & Unwin, 1959): a profound book accessible to the layman.

68

do prove is that, when the scale is small and basic enough, the indivisibility of nature manifests itself in simultaneity. The qualities of a wave are the opposite of those of a particle. Yet under certain circumstances an electron behaves as though it were both simultaneously.

I said that the Cubists were feeling their way to a new synthesis, which, in terms of painting, was the philosophical equivalent of the new synthesis taking place in scientific thinking. They were not, of course, directly influenced by this thinking. Although Planck published his Quantum Theory in 1901, its implications were not understood until the 1920s at the earliest, and by that time all the Cubist innovations had been made. Nor is it likely that the Cubists read Einstein in 1905. But this is not the point. The Cubists reached their conclusions independently. In their own subjects they too felt the challenge of the new mode of thought originating in the nineteenth century and now stimulated by the new technological inventions; they too were concerned with what was *interjacent*.

In order to appreciate the parallel more easily, let me repeat what I wrote when describing the Cubist method of painting:

The Cubists created a system by which they could reveal visually the interlocking of phenomena. And thus they created in art the possibility of revealing processes instead of static states of being. Cubism is an art entirely concerned with interaction: the interaction between different aspects: the interaction between structure and movement: the interaction between solids and the space around them: the interaction between the unambiguous signs made on the surface of the picture and the changing reality which they stand in for.

What the Cubists mean by structure, space, signs, process, is quite different from what nuclear physicists mean. *But the difference between the Cubist vision of reality and that of a great seventeenth-century Dutch painter like Vermeer is very similar to the difference between the modern physicists' view and Newton's: similar not only in degree but in emphasis.*

Such parallelism between different branches of culture and research is rare in history. It is probably confined to those periods which immediately precede a revolution.

The previous one in Europe was the Enlightenment. To emphasize once more the remarkable convergence of new factors which produced this parallelism in the period between 1900 and 1914, let us, for one moment, consider the film.

The film is *the* art-form of the first half of our century. It started in the late nineties as primitive fairground entertainment. By 1908 it had become the medium we would recognize today. By 1912 it had produced its first great master – D. W. Griffith in America. Technically, the film depends upon electricity, precision engineering, and the chemical industries. Commercially, it depends upon an international market: up to 1909 Pathé and Gaumont in France had a virtual monopoly; in 1912 the United States took over. Socially, it depends upon large urban audiences who, in imagination, can go anywhere in the world: a film audience is basically far more *expectant* than a theatre audience. It is no coincidence that one of the very first narrative films was based on Jules Verne. Artistically, the film is the medium which, by its nature, can accommodate most easily a *simultaneity of viewpoints*, and demonstrate most clearly *the indivisibility of events*.

I have taken so long to discuss Cubism without once mentioning Picasso because its full historic significance is seldom understood. Usually it is explained purely in terms of art history. By so-called marxist critics in Moscow it is condemned, together with Expressionism, Dadaism, and Surrealism, as modernist and decadent. To do this is ludicrously unhistorical. Dadaism and Surrealism were the result of the 1914 war. Cubism was only possible because such a war had not yet been imagined. As a group the Cubists were the last optimists in Western art, and by the same token their work still represents the most developed way of seeing yet achieved. It is to Cubism that the next serious innovators are bound to return.

Today the magnitude of the Cubists' achievement is unappreciated in the West because of our overpowering sense of insecurity and *Angst*. (Their paintings fetch high prices – but as treasures from another world.) It is unappreciated in the Soviet Union because there the official view of the visual arts is still that of the nineteenth century. When eventually the full Cubist achievement is appreciated,

it will not be possible to explain it in terms of personal genius alone. The comparison with the early Renaissance will again apply.

The Cubists were at a point of startling coincidence. They inherited from nineteenth-century art the revolutionary promise of dialectical materialism. They sensed at the turn of this century the promise of the new means of production with all its world implications. They expressed their consequent enthusiasm for the future in terms which are justified by modern science. And they did this in the one decade in recent history when it was possible to possess such enthusiasm and yet ignore, without deliberate evasion, the political complexities and terrors involved. They painted the good omens of the modern world.

We must now go back to 1907, before any Cubist picture had been painted and before the word itself had been coined. In the spring of that year Picasso painted *Les Demoiselles d'Avignon.*

36 *Picasso. Les Demoiselles d'Avignon. 1907*

The picture went through many stages and remains unfinished. Originally the composition included two men. One was a sailor, and the other entered the room carrying a skull. The room is in a brothel and the women are prostitutes. (The title derives from the fact that there was a brothel, which Picasso and his Spanish friends knew, in Barcelona, in a street named Avignon. But, since the title was not Picasso's own and was partly a joke, there is no reason to assume that Picasso was thinking of Barcelona.) The original presence of the man with a skull has prompted some critics to compare the subject with *The Temptations of St Anthony*. It seems as likely to have been another private reference to Picasso's own recent fears about venereal disease. In the final version of the picture the subject as such is hard to identify. We see simply five naked women, painted more brutally than any woman had been painted since the eleventh or twelfth century, since that time when woman was seen as a symbol of the flesh, of the physical purgatory in which man was condemned to suffer until he died.

Blunted by the insolence of so much recent art, we probably tend to underestimate the brutality of the *Demoiselles d'Avignon*. All his friends who saw it in Picasso's studio (it was not exhibited publicly until 1937) were at first shocked by it. And it was meant to shock. It was a raging, frontal attack, not against sexual 'immorality', but against life as Picasso found it – the waste, the disease, the ugliness, and the ruthlessness of it. In attitude it is in a direct line of descent from his previous paintings, only it is far more violent, and the violence has transformed the style. He is still true to his nature as a vertical invader. But instead of criticizing modern life by comparing it, as much in sorrow as in anger, with a more primitive way of life, he now uses his sense of the primitive to violate and shock the civilized. He does this in two ways simultaneously: by the subject matter and by the method of painting.

A brothel may not in itself be shocking. But women painted without charm or sadness, without irony or social comment, women painted like the palings of a stockade through which eyes look out as at a death – that is shocking. And equally the method of painting. Picasso himself has

72

said that he was influenced at the time by archaic Spanish (Iberian) sculpture. He was also influenced – particularly in the two heads on the right – by African masks. African art had been 'discovered' in Paris a few years previously. Later, primitive art was to be put to many different uses and quoted in many confused, complicated arguments. But here it seems that Picasso's 'quotations' are simple, direct, and emotional. He is not in the least concerned with formal problems. He is concerned with challenging civilization. The dislocations in this picture are the result of aggression, not aesthetics; it is the nearest you can get in a painting to an outrage. It is almost – to use an old anarchist term – an example of 'propaganda by deed'.

Its spirit is not so dissimilar from that of Lerroux's Barcelona speech of the year before: 'Enter and sack the decadent civilization . . . destroy its temples . . . tear the veil from its novices.'

I emphasize the violent and iconoclastic aspect of this painting because usually it is enshrined as the great formal exercise which was the starting point of Cubism. It was the starting point of Cubism, in so far as it prompted Braque to begin painting at the end of the year his own far more formal answer to *Les Demoiselles d'Avignon*, and, soon after that, Picasso and Braque worked 'rather like mountaineers roped together' (to quote Braque's phrase). Yet if he had been left to himself, this picture would never have led Picasso to Cubism or to any way of painting remotely resembling it. This is a vertical invader's 'propaganda by deed'. It has nothing to do with that twentieth-century vision of the future which was the essence of Cubism.

Yet it did mark the beginning of the great period of exception in Picasso's life. Nobody can know exactly how the change began inside Picasso. We can only note the results. *Les Demoiselles d'Avignon*, unlike any previous painting by Picasso, offers no evidence of *skill*. On the contrary, it is clumsy, overworked, unfinished. It is as though his fury in painting it was so great that it destroyed his gifts.

Such an interpretation also fits the other outstanding fact. Up to 1907 Picasso had followed his own apparently lonely road in painting. He did not influence his contemporaries in Paris and he appeared not to be influenced by them. After *Les Demoiselles d'Avignon* he became part

of a group. Apollinaire and his writer friends told him what he and they were searching for. He worked so closely with Braque that sometimes their pictures are barely distinguishable. Later he became a leader for Léger, Juan Gris, Marcoussis and others. It is as though with the disappearance of his prodigious skill Picasso was no longer isolated, no longer bound to his past, but open to the free interchange of ideas.

Apollinaire, who was extraordinarily perceptive about the spirit of people and of his time (far more so than about painting itself), noticed the change as it occurred. A few years after, in 1912, he wrote about it:

There are poets to whom a muse dictates their works, there are artists whose hand is guided by an unknown being who uses them like an instrument. There is no such thing for them as fatigue for they do not work, although they can produce a great deal at any time, on any day, in any country, in all seasons; they are not men but poetic or artistic instruments. Their reason is powerless against themselves, they do not have to struggle and their works show no trace of struggle. They are not divine, they can do without themselves, they are, as it were, an extension of nature. Their works by-pass the intelligence. They can be moving although the harmonies they strike are never humanized. And then there are other poets, other artists who wrestle. They struggle towards nature but have no immediate closeness to nature; they have to draw everything out of themselves, and no demon, no muse inspires them. They are alone and nothing gets expressed except what they themselves have stammered, stammered so often that sometimes after much effort and many attempts they are able to formulate what they wanted to formulate. Men created in the image of God, they will rest one day to admire what they have made. But the weariness! the imperfections! the labour!

Picasso was an artist like the former. There has never been a spectacle so fantastic as the metamorphosis he underwent in becoming an artist like the latter.*

What Apollinaire, with all his marvellous perception, could not realize is how much he and his friends and Braque had contributed to Picasso's metamorphosis. And he could not realize this because he did not then know that later, when the group no longer existed and Picasso was left to

* See *Les Peintres Cubistes* (Paris, 1913).

74

himself again, he would be transformed back into the first type of artist.

By painting *Les Demoiselles d'Avignon* Picasso *provoked* Cubism. It was the spontaneous and, as always, primitive insurrection out of which, for good historical reasons the revolution of Cubism developed. This surely becomes clear if one simply looks at seven relevant paintings in chronological sequence.

37 *Cézanne.*
Les Grandes
Baigneuses.
1898–1906

75

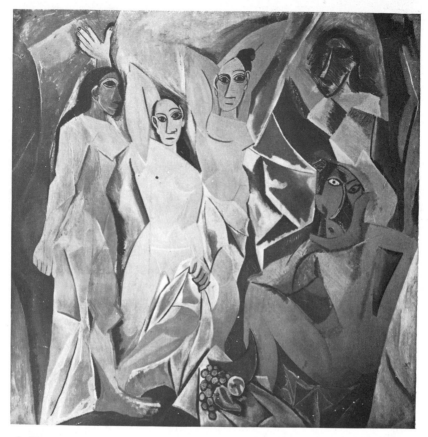

38 Picasso.
Les
Demoiselles
d'Avignon.
1907

39 *Braque.*
Nude.
1907–8

40 *Picasso.*
Landscape
with Bridge.
1908

41 *Braque.*
Houses
at Estaque.
1908

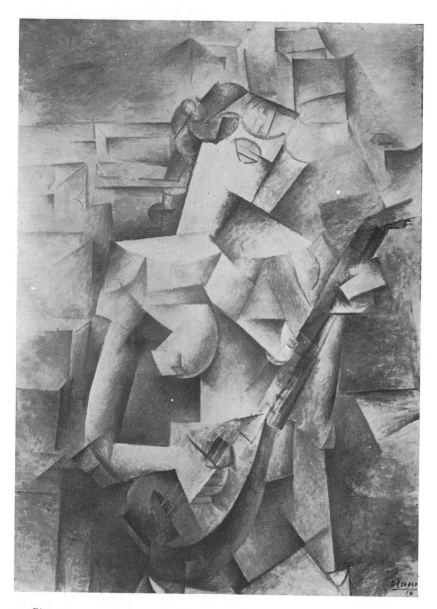

42 Picasso.
Girl with a
Mandolin.
1910

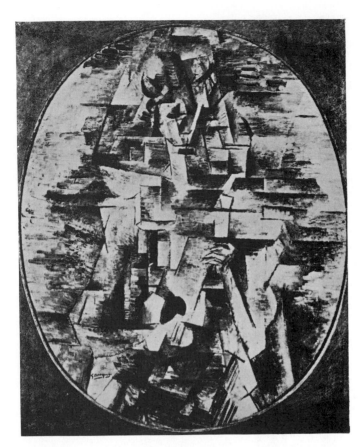

43 *Braque.*
Girl with a
Mandolin.
1910

81

After *Les Demoiselles* Picasso became caught up in what he had provoked. He became part of a group. That is not just to say that he had his own circle of friends – for this he had had before and would have afterwards. He became part of a group who, although they did not formulate a programme, were all working in the same direction. This is the only period in Picasso's whole life when his work to some extent resembles that of other contemporary painters. It is also the one period of his life when his work (despite his own denial of this) reveals an absolutely consistent line of development: from *Landscape with a Bridge* in 1908 to, say, *The Violin* of 1913. It was a period of great excitements,

44 *Picasso.*
The Violin.
1913

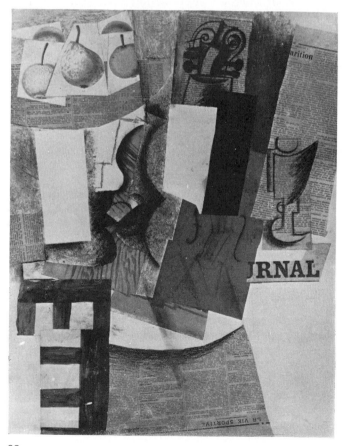

82

but also a period of inner certainty and security. It was, I believe, the only time when Picasso felt entirely at home. It is from that period, as much as from Spain, that he has since been exiled.

Within the group (although *group* is a word that is already a little too formal), within the companionship established, Picasso's energy and extremism were still outstanding. It was probably he who mostly pushed the arguments and logic to their full pictorial conclusions. (It was he who first thought of sticking extraneous material on to a canvas.) But it was probably his friends who sensed the pressure of what I have called the historical convergence which made Cubism possible. It was they, rather than he, who belonged to the modern world, and so were committed to it. He was committed to his work with them.

In 1914 the group dispersed. Braque, Derain, Léger, Apollinaire went to fight. Kahnweiler, who was Picasso's dealer, had to flee the country because he was German. Equivalent changes affected millions of people's lives.

Picasso was unconcerned about the war. It was not *his* war – another example of how tenuously he belonged to the life around him. Yet he suffered because he was left alone, and his loneliness was increased in 1915 by the tragic death of his young mistress. Under the pressure of this loneliness, he reverted to type. He re-became a vertical invader from the past. But before we examine the full consequences of this, I would like to show by example how, after 1914, the whole relationship between art and reality shifted.

It was not simply a question of dispersal. After the war most of the Cubists came back to Paris. Yet it was quite impossible for them to find or re-create the spirit and atmosphere of 1910. Not only was the whole aspect of the world different, not only had disillusion taken the place of hope, but their own position relative to the world had altered. Up to 1914 they had been ahead of events and their work prophetic. After the war events were ahead of them. Reality outstripped them. They no longer sensed – even intuitively – the drift of what was happening. The age of essential politics had begun. What was revolutionary was now inevitably political. The great innovator, the great revolutionary artist of the 1920s was Eisenstein. (James

83

Joyce belonged essentially to the pre-war world.) Some of the Cubists, such as Léger, and some of their followers, like Le Corbusier, acquired a political view and moved forward to become a new *avant-garde*. Others retreated. Max Jacob for example, once sceptical and heretical, became a baptized Catholic in 1915 and went to live in a monastery.

Nothing illustrates this change more vividly than the story of the ballet *Parade*. The Cubists had always despised the ballet as a pretentious and bourgeois form of entertainment. They preferred fairgrounds and the circus. In 1917, however, Jean Cocteau persuaded Picasso to collaborate with him and the composer Erik Satie in the creation of a ballet for Diaghilev. Diaghilev's company had been fashionable in Paris for ten years. In Russia it was a favourite of the Tsar. But Cocteau's plan was to break with tradition and produce a 'modern' spectacle. The title *Parade* was meant to suggest the circus and music-hall, and so exorcize the bourgeois ghosts.

Picasso went to Rome to work on the ballet. He designed the drop-curtain, the costumes, and the scenery. He also contributed ideas and suggestions. The drop-curtain is

45 *Picasso. Curtain for Parade. 1917*

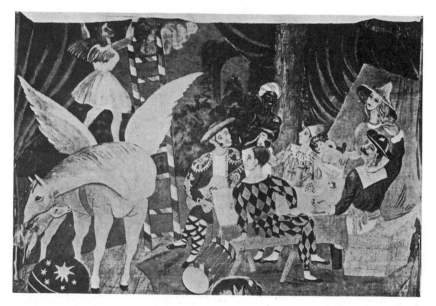

sentimental, perhaps deliberately so. But it fits the new *milieu* in which Picasso now found himself.

We made *Parade* [wrote Cocteau] in a cellar in Rome where the troupe rehearsed, we walked by moonlight with the dancers, we visited Naples and Pompeii. We got to know the gay futurists.

It is a long way from the violence of the *Demoiselles d'Avignon*, a long way from the austerity of the Cubist still-lifes, and a very long way from the Western Front in the third year of the World War.

The ballet itself was less conventional. And it might be argued that the drop-curtain was deliberately designed to lull the audience. There were seven characters in the ballet: a Chinese conjurer, an American girl, two acrobats, and three stage-managers. These last wore constructions made up of 'Cubist' elements which made them ten feet tall. One of them was French and 'wore' the trees of the boulevards, another was American and 'wore' skyscrapers, and the third was a horse. They moved about the stage like moving scenery and their purpose was to dwarf the dancers, so that these looked like puppets.

There was no coherent story but a lot of mimicry. Here are two of Cocteau's typical directions for the dancers. For the Chinese conjuror:

He takes an egg out of his pigtail, eats it, finds it again on the end of his shoe, spits out fire, burns himself, stamps on the sparks, etc.

For the American girl:

She runs a race, rides a bicycle, quivers like the early movies, imitates Charlie Chaplin, chases a thief with a revolver, boxes, dances a ragtime, goes to sleep, gets shipwrecked, rolls on the grass on an April morning, takes a snapshot, etc.

The ballet opened on 17 May at the Théâtre du Châtelet in Paris. The highly distinguished audience was outraged and suspected that the ballet had been designed to make them look ridiculous. As the curtain went down, there were threats to attack the producer, and cries of '*Sales Boches!*' Apollinaire saved the situation. Wounded, with a bandage round his head, in uniform, and wearing the Croix de

Guerre, he was able to appeal, as a patriotic hero, for tolerance.

He had also written the Introduction to the programme. In this he was enthusiastic and said that the ballet was a proof thac the modern movement, the new spirit in the arts, could survive the war. To the surviving spirit he gave the name super-realism or surrealism.

In eighteen months Apollinaire would be dead. (He died as Paris celebrated the armistice, and when, in his fever, he heard the crowds shouting that Kaiser William should be hanged, he thought, since his name was William, that they meant him.) Yet he had already named the next phase of the modern movement.

We do not know what Apollinaire would have thought later. I think he would have soon recognized that 'the new spirit' was not a simple continuation of that of the Cubists. The latter were prophets – whose prophecies, still to some extent unfulfilled, remain convincing. The Surrealists were wry commentators on a reality that was already outbidding them.

Exactly one month and one day before *Parade* opened in Paris, the French had begun their offensive against the Hindenburg line. Their objective was the river Aisne. The attack was a total disaster. The number of casualties was kept secret, but it is estimated that 120,000 Frenchmen were killed. This was happening about 150 miles away from the Théâtre du Châtelet. Utterly disillusioned and partly prompted by the example of the Russian Revolution of February, large sections of the French army were mutinying when the ballet opened. Once again the figures have been kept secret. But, without doubt, it was the most serious mutiny in a great army in modern history. There were many strange incidents. Everything had lost its reason. One small incident has since become famous. A contingent of infantrymen marched through the streets of a town. As they marched in proper order, they baa-ed like sheep to indicate that they were lambs being absurdly led to the slaughter.

Does not the grotesque absurdity of this scene which *was actually happening* make Cocteau's and Picasso's American girl seem unstartling and commonplace?

We must try to be very clear about the significance of

this – for there, in the Théâtre du Châtelet in 1917, was posed one of the recurring problems of art in our time.

Events in our century occur on a global scale. And the area of our knowledge has widened in order to encompass these events. Every day we can be aware of life-and-death issues affecting millions of people. Most of us close our minds to such thoughts except in times of crisis or war. Artists, whose imaginations are less controllable than most, have been obsessed with the problem: How can I justify what I am doing at such a time? This has led some to renounce the world, others to become over-ambitious or pretentious, yet others to stifle their imaginations. But since 1914 there cannot have been a serious artist who has not asked himself the question.

It would take a whole book to examine this dilemma fully. I want to make just one point in order to show why it is relevant to mention the Battle of the Aisne whilst discussing *Parade*. In 1917, Juan Gris was continuing to paint Cubist pictures – his best and some of the most

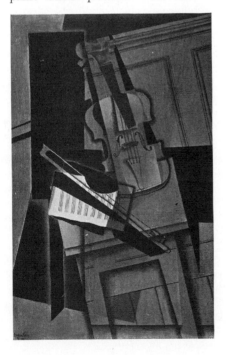

46 *Gris.*
The Violin.
1915

advanced Cubist pictures ever painted. (Because he was the most intellectual of the Cubists, Gris was the only one who, for a few years, could continue after Cubism as a movement had died. He could see the theoretical problems still to be solved, and he set out to solve them with all his intelligence.) These paintings are as far from the war as *Parade* – in fact farther. Yet why is it here irrelevant to mention the eight million dead – or as irrelevant as it can ever be?

The problem is a social one and it can only be answered socially. We have to consider the social function and content of Juan Gris's paintings and of *Parade*. We have already examined the social content of Cubism. As for the social function of Gris's paintings, at the time they had almost none. Gris was extremely poor during the war, and had the greatest difficulty in selling or exhibiting any of his pictures. In the long-term sense, their function was to express and preserve a way of seeing, based upon an order which accepted all the positive possibilities of modern knowledge. In other words Gris painted these pictures *as though the war had not happened*. You can say: he chose to fiddle whilst Rome burned. But, unlike Nero, he was not ultimately responsible for the fire and he was not in public. It was Gris's loneliness that made it possible for him to ignore the war without a loss of integrity. Even today there are still liable to be pockets of *exemption* anywhere and if an artist finds himself in one of these, the result can, paradoxically and in the fullness of time, be of considerable social value. European culture would be poorer if Gris had not continued to paint benign, untroubled still-lifes during the First World War. But one must always remember that success, by qualifying the loneliness, also destroys the genuineness of the exemption. Success turns an artist who continues to claim exemption into an escapist, and those who are escapists from their time are the first to be forgotten with their time. They are like flatterers who never outlast their patron.

The case of *Parade* was quite different from that of Juan Gris. *Parade* was very much a *public* manifestation. It was meant to be provocative and to shock. The justification given for this was that it expressed contemporary 'reality'. Cocteau rejected Apollinaire's adjective of surrealist, and actually insisted upon calling the work a *ballet réaliste*.

Obviously its 'reality' was not that of the Cubists – austere, ordered, hopeful. It was frenetic and irrational and, whether its creators realized it or not, it could only be justified by reference to the war. The audience who shouted '*Sales Boches!*' made the right connexion. But, according to their habit, they only used the connexion to add to their complacency.

The objective social function which *Parade* performed was to console the bourgeoisie whom it shocked. (I say *objective* to distinguish the true effect of the ballet from what its creators may subjectively have hoped it would achieve.) In this respect *Parade* set the precedent for a good deal of so-called 'outrageous' art that was to follow. Its shock-value was the result of its particular spirit – its disjointedness, its frenzy, its mechanization, its puppetry. This spirit was a reflection, however pale, of what was happening. And what was happening was infinitely more shocking on an infinitely more serious level. Why *Parade* – however beautifully Massine danced – can be criticized and finally dismissed as frivolous is not because it ignored the war, but because it pretended to be realistic. As a result of this pretence it shocked in such a way as to distract people from the truth. It substituted, as it were, an ounce for a ton. The madness of the world, they could say, was the invention of artists! The audience who shouted '*Sales Boches!*' felt, at the end of their evening, more patriotic than ever, more certain than ever that the war was noble, reasonable, etc. A performance of *Les Sylphides* would not have had the same effect.

The age of essential politics had begun. The baa-ing infantrymen knew this – even if they could not see a way out. Cocteau, Picasso, even Apollinaire did not yet realize it, because they still believed in the possibility of art staying separate. The bitter irony of this is revealed in the spectacle of Apollinaire pacifying a bourgeois audience, whom he loathed and despised, on account of the wounds he had received as their war hero: wounds from which in eighteen months he would die.

Stupid people often accuse marxists of welcoming the intrusion of politics into art. On the contrary, we protest against the intrusion. The intrusion is most marked in times of crisis and great suffering. But it is pointless to deny such

89

times. They must be understood so that they can be ended: art and men will then be freer. Such a time began in Europe in 1914 and continues still. The ballet *Parade* is one of the first examples in which we can see the difficulties facing art in the present situation. For the first time we see the modern artist serving, despite his own intentions, the bourgeois world and therefore sharing a position of doubtful privilege. The rest of the story of Picasso's life is the story of how he has struggled to overcome the disadvantages of this position.

When Picasso came to London in 1918 he stayed at the Savoy Hotel. He no longer saw couples at a café table beyond hope or redemption. And the place of acrobats or horse-thieves was taken by waiters and valets. It would be trivial to mention this, were it not typical of Picasso's new life. Having 'shocked' the distinguished and the wealthy, he joined them.

His former friends, and especially Braque and Juan Gris, considered his new life a betrayal of what they had once striven for. Yet the problem was not simple. Braque and Gris, in order to continue as before, had to retreat within themselves. Picasso chose instead to go the way of the world. The private details involved need not concern us. What we need to know is how his spirit, his attitudes, were changed.

The change was dramatic, as you can see immediately in this portrait of his future wife in an arm-chair:

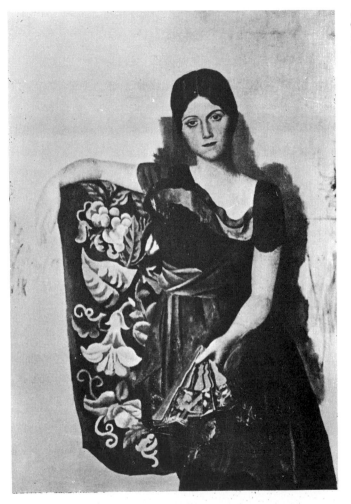

According to Apollinaire's distinction, Picasso has re-
become an artist of the first type. He has re-acquired his
prodigious skill, his uniqueness, and his ease. This particular
portrait is so stuffy – an *haute bourgeoise* complete with fan
in a glass case on the china cabinet – that distaste may
blind us somewhat to the skill. The skill is more obvious
in the drawing of *Bathers*.

91

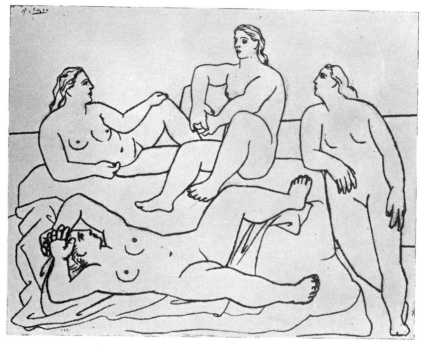

48 *Picasso.*
Bathers. 1921

The legend of Picasso as a magician now begins. It is said that he can do anything with a shape or a line. This legend is to culminate much later in the famous sequence of Picasso drawing with light from an electric torch in the film made by Clouzot and aptly called *Le Mystère Picasso*.

He did not of course revert to what he had been in 1906. He never forgot the experience of Cubism. The woman lying on her back in the *Bathers* is drawn in a way that would have been impossible before 1910. And soon Picasso was to re-apply the lessons of Cubism in a far more violent and original way. But, except on the very rare occasions when he has been deeply moved, the struggle and what Apollinaire called 'the stammering' has gone. The prodigy has been re-born.

Picasso was now not only successful, he was also exotic. The circle in which he moved could not have accepted him on any other terms except those of exoticism. Beneath his perfectly-made dinner-jacket he wore a bullfighter's cummerbund. For a ball given by Comte Étienne de Beaumont

he dressed as a matador. He designed three more ballets for Diaghilev. Compared with *Parade* they were conventional and romantic. One was set in Naples and the other two in 'picturesque' Spain.

The experience of being fêted and employed as an exotic magician, combined with the sense of isolation which has always accompanied Picasso's awareness of himself as a prodigy, re-awoke the vertical invader. Perhaps the sense of loss he must have felt about his Cubist friends contributed to the awakening. Aware of being exiled from the one period in which he had been accepted by others as an equal, in which he felt at home, he now became more sharply conscious of his other exile from Spain.

49 *Picasso as a matador.* *1924*

93

A frontal attack like *Les Demoiselles d'Avignon* was out of the question; Picasso was still enjoying his success. All that the vertical invader claimed was recognition of his origins. He had conquered but he needed to fly his own standard.

It was at this time that Picasso first began to caricature European art, the art of the museums. At first, and very gently, he caricatured Ingres.

50 *Ingres.*
Drawing.
1828

94

51 *Picasso.*
Madame
Wildenstein.
1918

Later and more obviously he caricatured the classic ideal, as found in Greek sculpture and in Poussin.

52 *Picasso.*
Women at
the
Fountain.
1921

53 *Poussin.
Eliezer and
Rebecca
(detail).
1648*

The word *caricature* may give the wrong impression.
Perhaps these works of Picasso are more like a performance
by an impersonator of genius. The performance is too skilful
to be considered a mere joke. Yet there is certainly an
element of mockery.

For the vertical invader these impersonations or caricatures serve two purposes. First they prove that he can do what the masters have done: that he – who has no terms of his own – can challenge them all on their own terms. Secondly they suggest that, if this is possible, the value and honour officially given to cultural traditions may be exaggerated. If a commoner can perform as a king, where is the justification for royalty? They are not made out of disrespect for the artists concerned, but out of contempt for the idea of a cultural hierarchy.

Perhaps I should add that, although such works prove Picasso's comparable skill, they are not as satisfying or profound as the originals, because there is a self-conscious division between their form and content. The way in which they are painted or drawn does not arise directly out of what Picasso has to say *about his subject*, but instead out of what Picasso has to say about art history. It is the limitation of pastiche: a pastiche always has two heads. Picasso gives Madame Wildenstein the mask of an Ingres; he could have given her the mask of a Lautrec, but it would have been socially undesirable. Ingres draws Madame Delorme as he sees her. It is true that he also idealizes and formalizes her, but these formalizations have become part of his way of seeing, they are the mode of his talent's obsession.

There was a second way in which the vertical invader claimed recognition. From the early twenties onwards Picasso began to make oracular statements about his art. Finding himself treated as a 'magician' – in the fashionable sense of the word – he began to discover within himself a more serious magical basis for his work.

The essence of magic is the primitive belief that the will can control the latent forces and spirits residing in all objects and all nature. The power to bewitch and the state of being possessed are superstitious legacies from this early belief. The Spanish *duende* is not far removed from magic. Generally speaking, some belief in magic persisted up to the stage of social development of the clan – and the clan, if not a continuing reality, was at least a memory in Spain.

Frazer in *The Golden Bough* defines magic as mistaking an ideal connexion for a real one.

Men mistook the order of their ideas for the order of nature, and hence imagined that the control which they have, or seem to have, over their thoughts, permitted them to exercise a corresponding control over things.

Magic is an illusion. But its relevance should not be underestimated in the modern world.* To some extent all art derives its energy from the magical impulse – the impulse to master the world by means of words, rhythm, images, and signs. Magic first led man to the beginnings of science. And now, modern science confirms, if not the practice, at least some of the concepts of magic. The concept of 'action at a distance', with which Faraday struggled and from which he created the concept of the field of force, was fundamental to magic. So also was the conviction that reality was indivisible. Magic offered a blueprint of a unified world in which division – and therefore alienation – was impossible. This blueprint, which had no more substance than a dream, has now become a scientific aim. Magic may be an illusion but it is less profoundly so than utilitarianism.

It is hard to say how conscious Picasso is of talking about his art in terms of magic. What he says is sincere; it describes what he feels when working. At the same time it emphasizes the difference between himself and those who buy his pictures and lionize him. He establishes his right to ignore a certain kind of reasoning. Instead he establishes a logic of his own through which he can express his sense of the mysterious power which he has brought with him from childhood and from the past.

I deal with painting as I deal with things, I paint a window just as I look out of a window. If an open window looks wrong in a picture, I draw the curtain and shut it, just as I would in my own room.

This is a perfect example of 'mistaking' an ideal connexion for a real one. Or again, expressed more abstractly: 'I don't work *after* nature, but *before* nature and with her.' This is a definition of magic.

The power which Picasso possesses means that he must be granted a special licence:

* For the role of magic in art, see *The Necessity of Art*, by Ernst Fischer (Penguin Books, 1963).

It is my misfortune – and probably my delight – to use things as my passions tell me. What a miserable fate for a painter who adores blondes to have to stop himself putting them into a picture because they don't go with the basket of fruit! How awful for a painter who loathes apples to have to use them all the time because they go so well with the cloth. I put all the things I like into my pictures. The things – so much the worse for them: they just have to put up with it.

On one level, Picasso is claiming here his right to adore blondes – in the flesh. Baskets of fruit notwithstanding, no painter has ever had to stop himself *painting* blondes! But on another level there is the implication that his passions, his will, can control 'things' – even against their wishes, and that by means of painting a 'thing', he possesses it.

He can be possessed himself, but not in the sense in which the word is understood in the Rue de la Boëtie, a fashionable street of antique-dealers and *objets d'art*, into which he moved in 1918.

The artist is a receptacle for emotions that come from all over the place: from the sky, from the earth, from a scrap of paper, from a passing shape, from a spider's web. That is why we must not discriminate between things. Where things are concerned there are no class distinctions.

This view of himself as an artist – the artist as receptacle – incidentally confirms how Picasso fits again into Apollinaire's first category. It also stresses the difference between his unified world of magic and the life around him in a class society. 'Where things are concerned there are no class distinctions' would make no sense to an antique-dealer – for him the very opposite is true. But it is a prerequisite for magic.

The primitive, magical bias of Picasso's genius is not only evident in his statements about art: he performs quasi-magical ceremonies as well. Here is an account by Roland Penrose of Picasso making pottery.

Taking a vase which had just been thrown by Aga, their chief potter, Picasso began to mould it in his fingers. He first pinched the neck so that the body of the vase was resistant to his touch like a balloon, then with a few dexterous twists and squeezes he transformed the utilitarian object into

100

a dove, light, fragile, and breathing life. 'You see,' he would say, 'to make a dove you must first wring its neck.'*

Of course this is a game. But play and magic are perfectly reconcilable. (All young children live through a phase of believing that the world is governed by desire or will.) And what is remarkable is how we feel Penrose, who is by no means an unsophisticated man, falling under the spell of this magic. He is induced to say that the dove breathes life! He has seen the dead turned into the living.

Picasso began to play with such transmutations in the early thirties and spasmodically he has continued up to the present. He takes an object and turns it into a being. He has turned a bicycle saddle and a pair of handlebars into a bull's head. He has turned a toy car into a monkey's face, some wooden planks into men and women, etc.

* See Roland Penrose's useful but entirely uncritical biography, *Picasso: His Life and Work* (Gollancz, 1958).

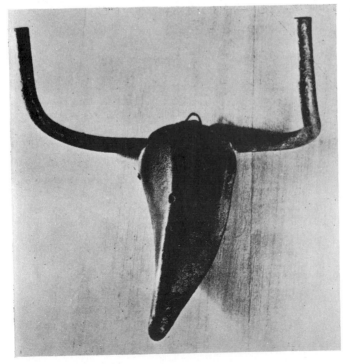

54 *Picasso. Bull's Head.* 1943

In the case of the *Bull's Head*, Picasso has not changed the form of the saddle and handlebars at all. He has scarcely touched them. What he has done is to *see* their possibility of becoming an image of a bull's head. Having seen this, he has placed them together. The seeing of this possibility was a kind of naming. 'Let this be a bull's head,' Picasso might have said to himself. And this is very close to African magic. Janheinz Jahn, in *Muntu*,* his study of African culture, writes:

It is the word, *Nommo*, that creates the image. Before that there is *Kintu*, a 'thing', which is no image, but just the thing itself. But in the moment when the thing is invoked, appealed to, conjured up through *Nommo*, the word – in that moment *Nommo*, the procreative force, transforms the thing into an image . . . the poet speaks and transforms thing-forces into forces of meaning, symbols, images.

Picasso is an intricately complex character. There is a part of him, cunning as any Rasputin, which exploits 'magic' in response to his success as a 'magician'. There is another part of him which uses it to procure himself licence as a public figure and to defend his independence. Yet another part is governed by sympathies and needs which are unusually close to the point where art really did emerge from magic.

We traced the influence of the vertical invader in Picasso's choice and treatment of subjects in the period before Cubism, before he became open to the influence of friends. We can see the same influence in his later work, when he was once again isolated.

In the late twenties Picasso became disillusioned with the *beau monde*. He retreated into himself. During the thirties his work was mostly introspective. (*Guernica*, as we shall see later, is a highly introspective work and only the political uses to which it was rightly put have confused people about this.) The imagery of this period is Spanish, mythological, and ritualistic. Its symbols are the bull, the horse, the woman, and the Minotaur.

At this time Picasso was involved in a passionate love-affair, and many of his best works were sexual in inspiration

* Faber, 1961.

102

55 *Picasso.*
Bull, Horse,
and Female
Matador.
1934

and content. In some of these he clearly identifies himself
with the Minotaur.

56 *Picasso.*
Sitting Girl
and Sleeping
Minotaur.
1933

The Minotaur represents the animal in the captivity of
an almost human form; it also represents (like the fable of
Beauty and the Beast) the suffering which is caused by aspir-
ation and sensibility being rejected because they exist in an
unattractive, that is to say untamed, uncivilized body.
Either way, the Minotaur suggests a criticism of civilization,
which inhibits him in the first case, and dismisses him in
the second. Yet, unlike the Beast, the Minotaur is not a
pathetic creature. He is a king. He has his own power –
which is the result of his physical strength and the fact that
he is familiar with his instincts and has no fear of them. His
triumph is in. sexual love, to which even the civilized
'Beauty' eagerly responds.

The emphasis of Picasso's work did not change again until
the end of the Second World War. Naturally, between
1930 and 1944 he painted many different subjects and
employed different styles. But all the great works of this
period – and in my view it is the period when, the Cubist
years excepted, he produced his best paintings and sculp-
ture – share the same preoccupation: a preoccupation with
physical sensations so strong and deep that they destroy
all objectivity and reassemble reality as a complement to
pain or pleasure. Put like that, it may sound as though
these works are Expressionist. They are not. Expressionism,
as in Egon Schiele's *Self-Portrait*, is concerned with
distortions which reflect violent emotions – *Angst*, awe,
pity, hatred, etc. Expressionism is produced by frustration.

57 *Schiele.*
Seated Male
Nude (self-
portrait).
1910

The paintings we are considering by Picasso are concerned with distortions which reflect sensations – sexual desire, pain, claustrophobia, etc. They are the result of a kind of self-abandonment.

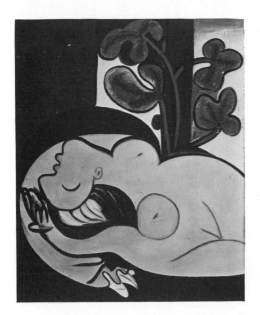

58 *Picasso.*
Nude on a
Black Couch.
1932

Perhaps the best way of making the point clear is by another comparison. In 1944, on the day Paris was liberated, Picasso painted a variation of Poussin's *The Triumph of Pan*. It is not one of Picasso's best paintings, and probably he simply painted it to fix his mind on something whilst he waited for news in his studio. But because the composition

59 *Poussin.*
The Triumph
of Pan.
1638–9

60 *Picasso.*
Bacchanale.
1944

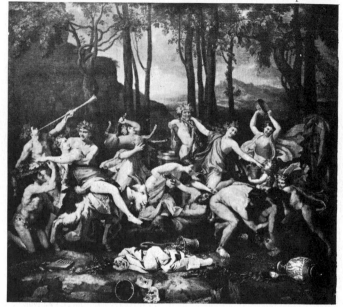

of the two pictures is so similar, we can distinguish all the more sharply the way Picasso's imagination was used to working.

The Poussin has been painted as a metaphor. The figures and the landscape, painted with considerable sensuous enjoyment of their particularity, nevertheless contribute and refer to a general idea: the idea of the social ease of pleasure; and this idea reveals a longing for a life freed from all restrictions because the interests of all are identical. The pleasure can be interpreted on a purely sexual level or more generally. Probably the two are linked. The desire to share sexual pleasure between more than two people, the orgy, has often been associated with plans for an ideal community. However, the important point is that the painting has been conceived as a unified metaphor.

106

In the Picasso, all metaphor and social idealism has disappeared. The scene is now portrayed entirely in terms of *sensation*. The distortions serve this end: one might describe them as tumescent — for the women with their small heads and expanding breasts represent very accurately the sensation of a woman to a roused man. The picture

60

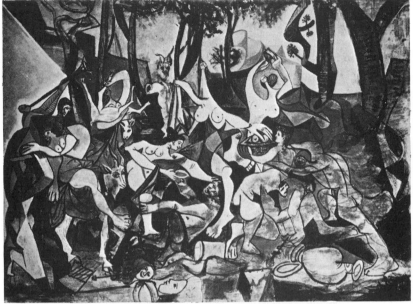

is made up of a series of urgent details. Only the grid of Poussin's original composition saves it from becoming entirely fragmentary. Compare, for example, the woman riding on the goat in the two paintings. It is surprising how unplastic Picasso's figure is. In the Poussin she simultaneously emerges from and belongs to all that surrounds her — like a fruit on a tree when you have already selected it with your eye, but not yet grasped it with your hand. That is what I mean by plasticity. But in the Picasso she is an assembly of separate parts — thigh, breasts, arm. Each part demands swift, separate, concentrated attention. It is now as though you were picking one fruit after another as your hand finds them, working so quickly that you can hardly notice the fruit in relation to the tree or to each other. This regression on Picasso's part (regression

because he has withdrawn from the complex and meta-phorical to the basic and singular) need not, in principle, mean a decline in expressive power. On the contrary, it has allowed Picasso, in other pictures, to say things never before said with such intensity. The impatience is the impatience of appetite: the addition rather than the cohesion of the parts expresses the mounting strength of a physical desire or sensation. I know of no other works in any medium or art which force you, as the best Picassos of this period do, so irresistibly into another man's or woman's or creature's skin. The effect is magical: it is as though we, looking at these figures, possess their sensations. I am this woman as she sleeps.

61 *Picasso.*
The Mirror.
1932

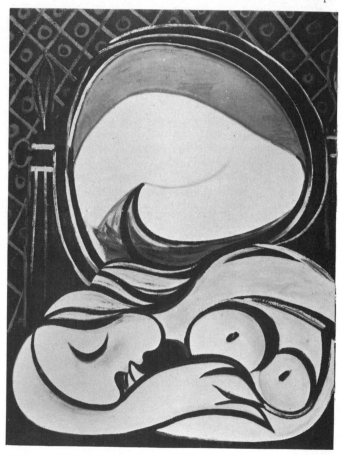

I am this one as she cries.

62 *Picasso.*
Weeping
Head. 1937

I am that woman as she turns to see me.

63 Picasso.
Figure. 1939

110

Yet the condition of such identification is the rejection of all intellectual conventions and systems. The displacement of the parts of the body is the visual counterpart of this rejection. It is as though we are brought so close to the sensation portrayed that the minimum distance needed for self-consciousness is denied. This is why the question: What does this picture mean? is almost unanswerable. Or at least the answer will at first sound like nonsense: it means being it.

Picasso's contribution to our culture through works like these is very considerable. He has made us aware of sensation as no other artist has done, and has extended the language of painting so that it may express this awareness. But such works depend for their significance on what they appear to undermine and destroy. Without Poussin, Picasso would not make sense. The distortions only count for us because, unlike children or animals, we can recognize and exactly measure them as such. Our awareness of physical sensation, as communicated by a work of art, is in fact dependent upon a very high level of self-consciousness. Picasso himself must have realized this creative dialectic: these works, apparently so free, are acts of homage to the European tradition of drawing. Every displacement is still startling. Each destruction is made for a specific creative purpose. One can feel the tension of the daring. Such work is like the boldest surgery.

After 1944 the tension began to go. The vertical invader became sentimental. The road by which he had invaded and conquered he now offered as an escape route. He issued invitations to Arcadia. Sensations are very near to pain. So sensations disappeared. Idealizations and jokes took their place. Picasso began to play Pan – as fathers play Father Christmas for their children. It wasn't that he lost his integrity. It was simply that he no longer knew what to do, and those who might have helped him, failed him. He was left with the most human and, for a modern artist, a most dangerous wish – the wish to give pleasure. And so it was that Picasso became institutionalized:

64 Picasso.
Triptych.
1946
65 Picasso.
Joie de vivre.
1946

Picasso's Arcadia is very unlike the traditional Arcadia in European painting. Compare *Joie de vivre* with, for example, Bellini's *Feast of the Gods*. The difference is not only

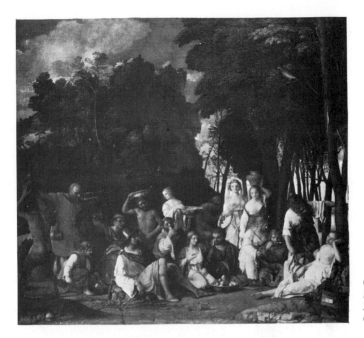

66 *Giovanni Bellini. The Feast of the Gods. 1514*

one of style. The traditional Arcadia represents an idealization of the contemporary world. Bellini's serving maids are not even country girls – let alone primeval creatures: they are sophisticated Venetian beauties. The men, in their expressions and attitudes, have all the sensibilities and weaknesses of rich courtiers. What Arcadia really means here is an ideal day in the country. Jean Renoir's film of *Une Partie de campagne* is in the same Arcadian tradition – though it concerns modern Parisians. Picasso's painting does not fit into this tradition. It makes no reference to the contemporary world, and ignores any development of knowledge or feelings. In the very broadest sense of the term it is unconcerned with *culture*. Its gaiety and vitality are of the kind which precede knowledge. Man and animal are still undifferentiated. And yet – and this is why it begins to be sentimental – the method of painting, the way of drawing is extremely schematic. It is a painting, not about sensations – which do indeed bring us very close to animals – but about an *idea*: the idea that we would all be happier if we had no ideas.

113

Other things could be said about this painting. As a kind of complement to its sentimentality, it also has wit. It works quite well as a decoration. But now more exaggeratedly and less consistently – Picasso chooses the primitive, the archaic.

He first made such a choice as a direct criticism of what he saw around him. An element of criticism still exists. In 1946 *Joie de vivre* affirmed life, even if of an excessively innocent kind, in the face of a terribly war-scarred Europe. But now, from the age of sixty-five onwards, Picasso's imagination begins to gravitate *naturally* towards the archaic. An attitude, once consciously held, has become a cast of mind.

Thus, in 1951, when Picasso painted *Massacre in Korea*, the effect is almost the opposite of what he intended. The soldiers, despite their sten-guns, are so heraldic and archaic

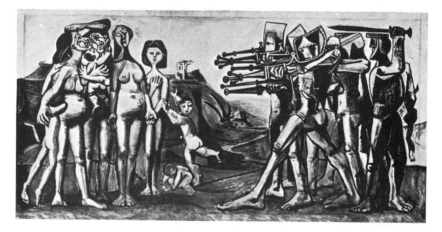

67 *Picasso. Massacre in Korea. 1951*

that either we lose the sense that this is a modern massacre, or else we consider the soldiers as symbols of an eternal, unchanging force of cruelty and evil. Either way our indignation, which the painting was meant to provoke, is blunted.

In 1952 Picasso painted one of his last major works on a theme of his own. Since then most of his paintings have been based on other artist's pictures. The work consisted of two large panels: *War* and *Peace*.

114

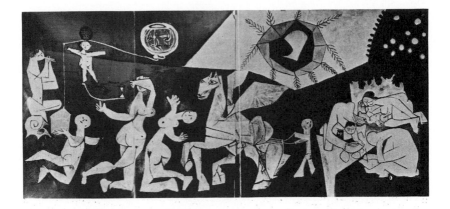

The panel *Peace* can well stand as a late testament of Picasso's. He has always been an artist concerned with men. He has never been an aesthete. And so in this panel we can read his comments, as an old man, on the human condition.

68 *Picasso.*
Peace. 1952

He is profoundly humanist – that is to say he believes the highest good is the happiness of man. In this picture (unlike the *Joie de vivre*) he suggests that culture is one of the conditions of this happiness. Such culture implies social organization. A woman reads a book. A man writes. Another plays pipes. A boy drives a horse. Two women dance. The scene is idyllic.

Yet what is remarkable is that there is no hint of the twentieth century in this vision. The objects which are included – an hourglass, a fish-bowl, a bird-cage, a reed pipe, the fire which the man on the right is making, the harness for the horse like one used for a plough – most of these actually suggest an earlier, simpler civilization.

And as if to emphasize this, there is then the magical element. The horse, like Pegasus, has wings. The sun has an eye. Birds fly in the fish-bowl, and fish swim in the bird-cage.

Of course one must not interpret such a picture literally. One must allow for inherited symbols, outlasting the civilization of their origin. One must grant poetic licence. My point is that the poetry of this painting is simple, fantastic, legendary, and, as it were, proverbial. It belongs to the tradition of folk stories and nursery rhymes:

115

I saw a fishpond all on fire
I saw a house bow to a squire
I saw a balloon made of lead
I saw a coffin drop down dead
I saw two sparrows run a race
I saw two horses making lace
I saw a girl just like a cat
I saw a kitten wear a hat
I saw a man who saw these too
And said though strange
 They all were true.

It is a painting which, to make us imagine peace and happiness, encourages us to believe in innocence rather than experience. Let us look at Picasso's *Peace* beside two other paintings.

Titian's *Shepherd and Nymph* is also an old man's vision of an idyllic world. It is also set in a kind of Arcadia with a shepherd and his pipes. Yet there is no question here of this

69 Titian.
Shepherd
and Nymph.
c. 1570

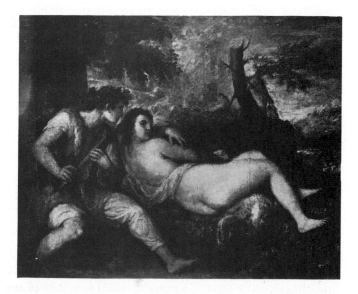

couple belonging to a simpler civilization. Everything about them suggests sophistication (look at the woman's hand and the quality of her skin) and experience: experience which, by its very nature, must include a sense of time

116

passing, hence the way she turns and he leans, as though both recognize that they must soon move. It is a vision whose beauty and spell depend upon the acceptance of change. The change when she turns round. The change when he, a moment ago, stopped playing. The change when he, in a minute, will move towards her. The change as the light fades. The change when she is dressed. It is a painting which, although it is nostalgic because Titian is old, affirms the maximum possible awareness of the world, the maximum possible experience of change.

It is always difficult to compare works of art across the centuries: the degrees and growing points of hope and fear differ so much. The Titian is largely an affirmative picture. Among modern works it makes me think of a poem by Yeats which is far more melancholy but which deals with the poet's consciousness of the same kind of experience. I quote it in contrast to the innocence of the nursery rhyme.

> 'Love is all
> Unsatisfied
> That cannot take the whole
> Body and Soul';
>
> *And that is what Jane said.*
>
> 'Take the sour
> If you take me
> I can scoff and lour
> And scold for an hour!'
>
> *'That's certainly the case,' said he.*
>
> 'Naked I lay
> The grass my bed;
> Naked and hidden away
> That black day';
>
> *And that is what Jane said.*
>
> 'What can be shown?
> What true love be?
> All could be known or shown
> If Time were but gone.'
>
> *'That's certainly the case,' said he.*

117

By comparison with the Titian, the dancing figures in the Picasso, for all their violent movements, are quite static. And because they are static, and 'Time is gone', they are innocent.

The other painting which it may be useful to put beside Picasso's *Peace* is a modern one: the *Composition aux deux perroquets* by Fernand Léger.

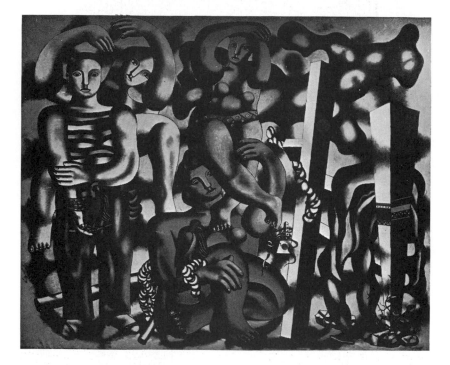

70 *Léger. Composition aux deux perroquets. 1935–9*

One of the main themes of Léger's later work was Leisure. A day out in the country. This brought Léger quite close to the Renaissance idea of Arcadia. And for Léger, like the Renaissance artists but unlike Picasso, this Arcadia had to be modern, had to be an idealization of the present. The Renaissance Arcadia was a vision of the courtly life freed from the intrigues of the city. Léger's Arcadia is a vision of the modern world granted plenty and a twenty-hour week.

And how naturally – even in an 'unrealistic' figure

118

composition – Léger maintains contact with the modern, industrialized world! His figures never slip away out of history into timelessness like Picasso's do. The man's shirt is machine-made. The posts which reach up to touch the clouds are twentieth-century architectural units. The ropes might be made of nylon. The miracles are no longer mysterious (like the fish in the bird-cage) but the result of human control. For Picasso, acrobats have always been wandering players who belong nowhere and are never still. For Léger, acrobats were builders who made constructions of their bodies to transcend nature and gravity. For Picasso their appeal lay in their elusiveness. For Léger it lay in their collective skill. The implication of this painting is that everything ought to be able to be controlled and constructed for man's pleasure – even the clouds in the sky.*

You may say this is naïve and only another form of innocence. But here we must make a distinction between innocence as an aim of experience, and innocence as a natural state of being. The former is a social idea which, like the concept of Utopia, is the result of men seeing the possibility of a future which could be better than the corrupt present. Innocence *as a natural state of being* is by definition changeless. No such thing exists. The theoretical possibility of such a state inspired Rousseau – but part of his greatness was that he never glossed over or hid the contradiction in his theory. In Picasso's case his belief in a natural state of innocence is a dream in which he only half believes, but which allows him to retreat deeper and deeper back into himself and his strange isolation.

If we compare the relationship of the figures to one another in the two paintings, the two different interpretations of the meaning of innocence are confirmed. Léger's is essentially a social attitude; Picasso's essentially a private one. In the Léger, the four figures are so united that it is quite difficult for the eye to separate them. Each is not only aware of the others but is dependent upon them. Although their faces are calm, their hands express the utmost tenderness. In the Picasso, there is no relationship

* For a more detailed study of Léger's view of modern man, see this author's articles in the April and May 1963 issues of *Marxism Today*.

between any of the figures – even the mother, whilst feeding her baby at her breast, is reading. The two women dancing suggest a collision rather than a couple. The only possible connexion one can find anywhere is the boy in the bottom left corner touching the bird-cage, which is attached by a string to the stick of the boy doing a balancing act above. And this is only a trick of drawing and perspective; a purely formal connexion. Otherwise each person, like a sleep-walker, pursues his own dream.

I have tried to show you, on the evidence of paintings from 1900 to 1952, how Picasso's imagination and intuitions have always presented him with an alternative to modern Europe: the alternative of a simpler, more primitive way of life. The Cubist period from 1907 to 1914 was the great exception to this. Then, the influence of friends and of other artists led him to believe for a short while in the opposite alternative: that of a more complex, more highly organized, more productive way of life. Except for this Cubist period, his genius has always owed allegiance to the comparatively primitive. It is this allegiance which underlay his self-identification with outcasts in the so-called Blue and Pink periods. It is this which inspired the rage of the *Demoiselles d'Avignon*. It is this which explains the fancy-dress and magic with which he protected himself after the First World War. It is this which was the secret of the physical intensity of his work in the thirties and early forties when he was painting autobiographically. It is this which is now the excuse for the sentimental pantheism of most of his original paintings (original as opposed to his variations on the themes of other artists) since 1944.

Reality, Lenin used to say, is slyer than any theory. What we have so far argued does not begin to explain *everything* about Picasso. But it can, I think, bring us nearer to understanding what at first seemed to be a mystery. What is the power of Picasso's personality? What is the experience that lies behind the expression of his eyes which nobody can resist? What is the connexion, if any, between his temperament and his success? We are now at the point where we can at last suggest an answer. Although the answer, as you will see, leads to another and most unlikely question.

A few pages back I mentioned Jean-Jacques Rousseau. It is he who can give us the terms of reference with which to place and define Picasso's subjective experience.

It is a commonplace today that one reads history the better to understand the present. And one wants to understand the present so that one can mould the future. In the minds of thinking men the present is always under attack from the past and future simultaneously. Those in revolt are usually inspired by a vision of the future. Occasionally – as with the Jacobites, or the Carlists in Spain – they are inspired by a vision of the past. Yet it is a constant truth that the past, if it could, would always overthrow the present. Every historical phase has the moral equipment with which to condemn the one that follows it. There are two reasons for this. First, because the moral code of a period is specifically designed to maintain the *status quo* and to prevent a new social class gaining power; secondly, because a development in social organization from the comparatively simple to the comparatively complex is bound to be offensive to any morality, since the function of morality is to simplify.

Rousseau was the first to perceive this contradiction between progress and morality. Why, he asks, did Diogenes have to search everywhere looking for a man? Because Diogenes 'sought among his contemporaries a man of an earlier period'.

Appalled by his own society, and pushing the logic of the contradiction back and back to its starting-point, Rousseau invented the 'noble savage', innocent and happy in a natural state. Perhaps it is wrong to refer to the noble savage as an invention; rather he was an idealization – bearing roughly the same relation to reality as a sculpture by Praxiteles does to the human body. The purpose of the idealization was to condemn – and condemn utterly – the present. At the beginning of the *Origin of Inequality*, Rousseau wrote:

The times of which I am going to speak are very remote: how much are you changed from what you once were! It is, so to speak, the life of your species which I am going to write, after the qualities which you have received, which your education and habits may have depraved, but cannot have

121

entirely destroyed. There is, I feel, an age at which the individual man would wish to stop: you are about to inquire about the age at which you would have liked your whole species to stand still. Discontented with your present state, for reasons which threaten your unfortunate descendants with still greater discontent, you will perhaps wish it in your power to go back.

There were other thinkers whose influence was more precise than Rousseau's. He is a key figure because he expressed a general imaginative and moral attitude.

I have seen [he said] men wicked enough to weep for sorrow at the prospect of a plentiful season; and the great and fatal fire of London, which cost so many unhappy persons their lives or their fortunes, made the fortunes of perhaps ten thousand others. Let us reflect what must be the state of things when men are forced to caress and destroy one another at the same time; when they are born enemies by duty, and knaves by interest. It will perhaps be said that society is so formed that every man gains by serving the rest. That would be all very well, if he did not gain still more by injuring them.

'The state of things when men are forced to caress and destroy one another at the same time' is one of Kafka's principal themes. And Kafka is so important and horrific as a writer not because he was neurotic, but because, a hundred and fifty years later, he too was a prophetic witness.

What Rousseau found to condemn in the eighteenth century, thinking sometimes of an early capitalist England and sometimes of an absolutist France, became more and more obvious in the nineteenth and twentieth centuries. He is the first sceptic of the coming age of faith in progress. But this same scepticism could be used, in the name of progress, to criticize society. To society he opposed Nature; to the corrupt, over-civilized, and greedy he opposed 'the noble savage'.

Not surprisingly, Rousseau's attitude was put to many different uses. He inspired Jefferson's American Declaration of Independence. Robespierre looked upon him as a master. The revolutions and struggles for national unity and independence that followed the French example – in Italy, Greece, Poland, Russia – were all ideologically

influenced by him. It was he who made Liberty, Equality, Fraternity, the *natural* rights of the *natural* man, because man was naturally free and good. In all these cases his attitude was an example for those making or attempting bourgeois revolutions.

Yet, later and sometimes even at the same time, his attitude was an encouragement to those who were disillusioned with bourgeois society. It is in this role that he can be claimed as the father of Romanticism, for, however diverse the Romantics from the early Wordsworth to Heine, all of them looked to nature to support them in their criticism of bourgeois society: all of them shared a passion for the wild as opposed to the tamed.

When I read the following passage, written by Rousseau in 1754, I think of a picture painted three generations later.

An unbroken horse erects his mane, paws the ground, and starts back impetuously at the sight of the bridle; while one which is properly trained suffers patiently even whip and spur: so savage man will not bend his neck to the yoke to which civilized man submits without a murmur, but prefers the most turbulent state of liberty to the most peaceful slavery. We cannot, therefore, from the servility of nations already enslaved, judge of the natural disposition of mankind for or against slavery; we should go by the prodigious efforts of every free people to save itself from oppression. I know that the

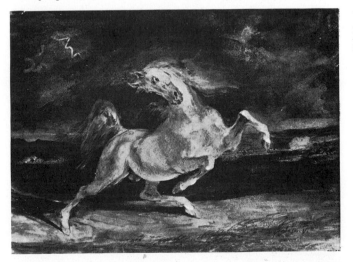

71 *Delacroix.*
Horse
Frightened
by a Storm.
1824

123

former are for ever holding forth in praise of the tranquillity they enjoy in their chains, and that they call a state of wretched servitude a state of peace: *miserrimam servitutem pacem appellant*. But when I observe the latter sacrificing pleasure, peace, wealth, power, and life itself to the preservation of that one treasure, which is so disdained by those who have lost it; when I see free-born animals dash their brains out against the bars of their cage, from an innate impatience of captivity; when I behold numbers of naked savages, that despise European pleasures, braving hunger, fire, the sword, and death, to preserve nothing but their independence, I feel that it is not for slaves to argue about liberty.

For nearly a hundred years all revolts and protests in Europe – whether political or cultural, left-wing or right-wing – were ideologically dependent upon an idealization of the past, or at least upon an idealization of the simple and natural as against the complex and artificial. This was the mode of the bourgeois revolutionary's thought. The noble savage was the genius of his revolt.

In the middle of the nineteenth century the revolutionary initiative passed to the working class, and the mode of revolutionary thought changed. Instead of simplifying man to his original 'essence', the emphasis was now on releasing what man *could become* from what he was at present forced to be.

As early as the 1820s Saint-Simon had realized that the only hope for a juster society was through more industrialization, not less. It was as though a point of no return had been reached – it was impossible to turn back, one could only go on. Justification could no longer be sought in the past, but only in the future.

As industrialization increased, experience and habits reinforced this view. The workers began to become aware of their growing political power. At the same time, increasingly cut off from the countryside and tradition, they began to lose any natural sense of the past. A sense of class took the place of a sense of tradition. The beginning was the bottom of the scale at which they were forced to live. Slavery – or the equivalent of it which they suffered – was primeval.

The nature of industrial work had a similar influence. For peasants, work is a continuous response to a natural

124

cycle – so that work can be equated with a man's whole life. For an industrial proletariat their work, their labour is what they sell in order, having worked, to buy the means to live. For the proletariat, work, therefore, is equated with paying a ransom to the future. The increased division of labour in industry encouraged the same way of thinking. Each job only made sense at a later stage. The pawnshop was more than a bitter fact of everyday life: it too was a token of a way of living and hoping. From the pawnshop, one of the most greedy and grubby refinements of capitalism, it was only one step to the conviction of socialism. Tomorrow we shall redeem what belongs to us.

Communism [wrote Marx in 1844] is the positive abolition of private property, of human self-alienation, and thus, the real appropriation of human nature, through and for man. It is therefore the return of man himself as a social, that is, really human being, a complete and conscious return which assimilates all the wealth of previous development.

In this quotation you can see how the 'noble savage' has 'returned' as part of a larger idea – and how, in the process, he has been transformed. The transformation is the result of a new, more scientifically based understanding of progress; an understanding which was impossible until men were faced with the terrible contradictions of the wealth and poverty of nineteenth-century industry.

The publication of *The Communist Manifesto* in 1848 was the first full exposition of the new revolutionary attitude. Paris of the Commune of 1871 was the first battlefield. The Russian Revolution of 1917 was the first victory.

Yet the new attitude was by no means exclusively marxist. The Fabians, for example, were, in their thinking, just as far removed, and for the same reasons, from the early-nineteenth-century revolutionaries. Only the anarchists were still close to the earlier attitude, but anarchism, as we have seen, became a political force in countries which were still at an historically earlier stage.

Today, even bourgeois revolutions in former colonial countries are planned and justified in terms of the new attitude. No society or empire is any longer criticized by reference to nature, but by reference to other societies at a

higher stage of economic development. Perhaps the cosmonaut – with all that he implies of technical resources and of liberation from the earth itself – will soon take the place of the worker as a revolutionary image. Perhaps the one-time 'savage' demanding an end of his exploitation and the right to the most modern means of production has already taken that place. Events and their developments have put an end to the revolutionary role of the imaginary 'noble savage' – whilst confirming and clarifying his historic importance during one century.

How does this give us better terms of reference for understanding Picasso? Picasso arrived in Paris as a vertical invader. He came from Spain, which was still a feudal country with certain strong pre-feudal traditions. The fact that he was a prodigy and the bias of his temperament appear to have made him particularly open to the influence of the primitive aspects of Spain. Although, after he settled in Paris, he had little direct contact with his own country, this influence has in no way diminished and, in some respects, has increased. It seems that Picasso has consciously tried to preserve it.

Yet there is nothing primitive about the way Picasso has lived. His parents were not peasants, but impoverished middle-class people with artistic and intellectual leanings. When he left home, he mixed with intellectuals in Barcelona and Madrid. After a few years of poverty in Paris he became highly successful and moved into a wealthy bourgeois milieu. Later he left it and lived his own life as a rich sophisticated bohemian.

To appreciate more clearly the dualism of Picasso's attitude, it is worth while comparing him with an artist like Brancusi. Brancusi, the son of a peasant farmer in Roumania, was also anxious to preserve, *as a modern twentieth-century artist*, the simplicity and closeness to nature of his early background. He believed that innocence was essential to art. 'When we cease to be children', he said, 'we are already dead.' He brought with him the sense of moral superiority of a man from the past. Discussing the dedication necessary for an artist, he said: 'Create like a god, rule like a king, and work like a slave.' Brancusi, however, lived in the same way as he worked: simply, austerely, and – in terms of the demands of modern Paris or New York –

somewhat helplessly. He either would not or could not cooperate except on his own terms – and they were the terms of a hermit who had chosen to live in the desert of modern life, faithful to an early vision of essentials.

72 *Brancusi.*
The Bird.
1915

73 *Brancusi*
in his studio,
1946

It is true that Picasso has likewise preserved his independence, but he has also been able to cooperate. His commercial success is a token of this cooperation. So also are the films he appears in, the photographs he has posed for, the interviews he has given. However innocent his art, his career bears all the marks of a very shrewd business mind which has the measure of the modern world.

This is not to suggest that Picasso is hypocritical. Nor is it to suggest that, because of his success, he is a less serious artist than Brancusi. We must rid ourselves of the romantic idea that worldly failure is in itself a virtue. In itself it is just an unhappiness. Picasso has a different temperament from Brancusi, and his temperament has enabled him to preserve his genius *and* be successful.

Yet to explain it like that in terms of temperament is to beg the question. Temperament is simply a convenient term for explaining away what a man is. The temperament must be analysed. This can be done physiologically and psychologically by direct examination. It can also be done – and this has so far been my purpose in this essay – historically.

A temperament is partly the result of social conditioning. But writers have not paid enough attention to the way history can be subjectively active in the creation of a character. I say *subjectively* because I am not talking about the direct effect of historic events or trends, but about the historical content residing in particular character-traits, habits, emotional attitudes, beliefs: and how this content, which may be highly inconsistent in objective terms, then expresses itself through the formation of a specific character. In common speech the truth of this is recognized when outstanding cases are being considered: 'He is ahead of his time', 'He belongs to another period', 'He should have been born during the Renaissance', etc. But in fact the same applies to every character. The whole of history is part of the reality which consciousness reflects. But a character, a temperament, is maintained by emphasizing certain aspects of reality – and therefore of history – at the expense of others.

The subject is too distant for us to pursue. In relation to the arts, it is far more directly concerned with the novel than with painting. (All great novels are histories of man-

kind for this reason.) The only point I want to make here is that certain temperaments and their experiences can be most easily understood if defined in historical terms. The precision of the understanding then depends upon the precision of the terms used. I believe that this applies to Picasso.

We have already said that Picasso was an invader. This is what he was in relation to Europe. *But within himself he was, at one and the same time, a 'noble savage' and a bourgeois 'revolutionary'. And within himself the latter has idealized the former.*

Why has he idealized himself? Or, to put it more accurately, why has he so carefully preserved the primitive bias of his genius that it can serve as the genius of a 'noble savage'? It has not been the result of self-love or vanity. By idealizing his 'noble savage', he condemns, like Rousseau, the society around him. This is the source of his sincere conviction that he has been a revolutionary all his life. It is this which has made him *feel* a revolutionary – although in fact few Europeans of his generation have had less real contact with modern politics.

If he had returned to Spain, he would doubtless have developed differently. In Spain he would no longer have been aware of himself as a 'savage'. This awareness was the result of the difference between himself and his foreign surroundings. For others this difference has made Picasso exotic, and to some degree he has encouraged this, for the more exotic he becomes the more of the 'noble savage' he can find within himself, and the more of the 'noble savage' he can find within himself the more forcefully he can condemn those who patronize him by considering him exotic. Such is the paradox in Picasso's attitude to fame.

The fact that another part of Picasso is a bourgeois 'revolutionary' is equally plausible. He came from a middle class which had not yet achieved its revolution. As a student in Barcelona and Madrid he mixed with other middle-class intellectuals with anarchist ideas. Anarchism was the one political doctrine of the second half of the nineteenth century which continued the eighteenth-century tradition of Rousseau – believing in the essential goodness and simplicity of man before he was corrupted by institutions. After he left Spain, Picasso took no further part in

politics for thirty years. At the same time his life was comparatively unaffected by political events. For many of his contemporaries the First World War was a terrible awakening to the realities of the twentieth century. Picasso was not in the war and appears to have given it no thought. His interest in politics was only re-awakened by what happened distantly *in his own country* during the Spanish Civil War. In so far as he belongs to politics, Picasso belongs to Spanish politics. And in Spain a bourgeois revolutionary is still a possibility.

We can now begin to understand why Picasso claims, like no other twentieth-century artist, that what he *is* is more important than what he does. It is the existence of the 'noble savage', not his products, that offers the challenge to society.

We can begin to understand something of the magnetism of his personality, of his power to attract allegiance. This is the result of his own self-confidence. Other twentieth-century artists have been victims of doubt, awaiting the judgement of history. Picasso, like Napoleon or Joan of Arc, believes that he is *possessed* by history – that he is the judgement for which others have been waiting.

We can begin to understand his ceaseless productivity. No other artist has had such an output. Although what he *is* is more important than what he does, it is only by working that his two selves can be maintained. In modern Europe art is the only activity in which the 'noble savage' can be himself. Thus the 'noble savage' has to paint in order to live. If he did not live, the 'revolutionary' would have nothing to live for. He does not go on painting to make his paintings better – indeed he resolutely denies the very idea of such 'progress'; he goes on painting in order to prove that he is still what he was before.

On a more objective plane the phenomenon of his success becomes more understandable. His success, as we saw, has little to do with his work. It is the result of the *idea of genius* which he provokes. This is acceptable because it is familiar, because it belongs to the early nineteenth century, to Romanticism, and to the revolutions which, safely over, are now universally admired. The image of his genius is wild, iconoclastic, extreme, insatiable, free. In this respect he is comparable with Berlioz or Garibaldi or Victor Hugo.

130

In the guise of such genius he has already appeared in hundreds of books and stories for a century or more. Even the fact that he or his work is outrageous or shocking, is part of the legend and therefore part of what makes him acceptable. It would be wrong to suggest that each century has its exclusive type of genius. But the *typical* genius of the twentieth century, whether you think of Lenin or Brecht or Bartok, is a very different kind of man. He needs to be almost anonymous: he is quiet, consistent, controlled, and very conscious of the power of the forces *outside* himself. He is almost the exact opposite of Picasso.

Finally, we can begin to understand Picasso's fundamental difficulty: a difficulty that has been so disguised that scarcely anybody has recognized it. Imagine an artist who is exiled from his own country; who belongs to another century, who idealizes the primitive nature of his own genius in order to condemn the corrupt society in which he finds himself, who becomes therefore self-sufficient, but who has to work ceaselessly in order to prove himself to himself. What is his difficulty likely to be? Humanly he is bound to be very lonely. But what will this loneliness mean in terms of his art? It will mean that he does not know what to paint. It will mean that he will run out of subjects. He will not run out of emotion or feelings or sensations; but he will run out of subjects to contain them. And this has been Picasso's difficulty. To have to ask of himself the question: What shall I paint? And always to have to answer it alone.

2
THE
PAINTER

is now free to paint anything he chooses. There are scarcely any forbidden subjects, and today everybody is prepared to admit that a painting of some fruit can be as important as a painting of a hero dying. The Impressionists did as much as anybody to win this previously unheard-of freedom for the artist.

Yet, by the next generation, painters began to abandon the subject altogether, and paint abstract pictures. Today the majority of pictures painted are abstract.

Is there a connexion between these two developments? Has art gone abstract because the artist is embarrassed by his freedom? Is it that, because he is free to paint anything, he doesn't know what to paint? Apologists for abstract art often talk of it as the art of maximum freedom. But could this be the freedom of the desert island?

It would take too long to answer these questions properly. I believe there is a connexion. Many things have encouraged the development of abstract art. Among them has been the artists' wish to avoid the difficulties of finding subjects when all subjects are equally possible.

I raise the matter now because I want to draw attention to the fact that the painter's choice of a subject is a far more complicated question than it would at first seem. A subject does not start with what is put in front of the easel or with something which the painter happens to remember. A subject starts with the painter deciding he would like to paint such-and-such because for some reason

or other he finds it meaningful. A subject begins when the artist selects something for *special mention*. (What makes it special or meaningful may seem to the artist to be purely visual – its colours or its form.) When the subject has been selected, the function of the painting itself is to communicate and justify the significance of that selection.

It is often said today that subject matter is unimportant. But this is only a reaction against the excessively literary and moralistic interpretation of subject matter in the nineteenth century. In truth the subject is literally the beginning and end of a painting. The painting begins with a selection (I will paint this and not everything else in the world); it is finished when that selection is justified (now you can see all that I saw and felt in this and how it is more than merely itself).

Thus, for a painting to succeed it is essential that the painter and his public can agree about what is significant. The subject may have a personal meaning for the painter or individual spectator; but there must also be the possibility of their agreement on its general meaning. It is at this point that the culture of the society and period in question precedes the artist and his art. Renaissance art would have meant nothing to the Aztecs – and vice versa. (If, to some extent, a few intellectuals can appreciate them both today it is because their culture is an historical one: its inspiration is history and therefore it can include within itself, in principle if not in every particular, all known developments to date.)

When a culture is secure and certain of its values, it presents its artists with subjects. The general agreement about what is significant is so well established that the significance of a particular subject accrues and becomes traditional. This is true, for instance, of reeds and water in China, of the nude body during the Renaissance, of the animal head in Africa. Furthermore, in such cultures the artist is unlikely to be a free agent: he will be employed *for the sake of particular subjects*, and the problem, as we have just described it, will not occur to him.

When a culture is in a state of disintegration or transition the freedom of the artist increases – but the question of subject matter becomes problematic for him: he, himself, has to choose for society. This was at the basis of all the

increasing crises in European art during the nineteenth century. It is too often forgotten how many of the art scandals of that time were provoked by the choice of subject (Géricault, Courbet, Daumier, Degas, Lautrec, Van Gogh, etc.).

By the end of the nineteenth century there were, roughly speaking, two ways in which the painter could meet this challenge of deciding what to paint and so choosing for society. Either he identified himself with the people and so allowed their lives to dictate his subjects to him; or he had to find his subjects within himself as painter. By *people* I mean everybody except the bourgeoisie. Many painters did of course work for the bourgeoisie according to their copy-book of approved subjects, but all of them, filling the Salon and the Royal Academy year after year, are now forgotten, buried under the hypocrisy of those they served too sincerely.

Those who identified themselves with the people (Van Gogh, or Gauguin in the South Seas) found new subjects and renewed, in the light of the lives of those for whom they saw, old subjects. A landscape by Van Gogh has a totally different meaning (and reason for being selected) from a landscape by Poussin.

Those who found their subjects within themselves as painters (Seurat or Cézanne) strove to make their method of seeing the new subject of their pictures. In so far as they succeeded in doing this, as we saw in the case of Cézanne, they changed the whole relationship between art and nature, and made it possible for every spectator to identify himself with the vision of the painter.

Those who took the first solution were mostly driven on by the terrible pressures of loneliness. Because they wanted to 'belong' they became socially conscious. Having become socially conscious, they wanted to change society. It is in this sense only that one can say that they were political, and that they chose their subjects by the standards of a future society.

Those who took the second solution were more reconciled to being isolated. Their devotion was to the logic of their vocation. Their aim was not to submit their imagination to the demands of the lives of others, but on the contrary to use their imagination to gain an ever-increasing control

135

of their art. They chose their recurring subject – which was their method of seeing – to create the standards of a future art.

No artist will fit neatly into either of these categories. I am deliberately being diagrammatic so as to shed some light on a very complex problem. The important artists of this century can also be approximately divided into the same two categories: those whose method of seeing transcends their subjects: Braque, Matisse, Dufy, de Staël, etc., and those whose choice of subject insists upon the existence of another (tragic or glorious) way of life, distinct from that of the bourgeoisie: Rouault, Léger, Chagall, Permeke, etc.

To which does Picasso belong? He has answered for himself:

I see for the others. That is to say I put down on the canvas the sudden visions which force themselves on me. I don't know beforehand what I shall put on the canvas, even less can I decide what colours to use. Whilst I'm working I'm not aware of what I'm painting on the canvas. Each time I begin a picture, I have the feeling of throwing myself into space. I never know whether I'll land on my feet. It's only later that I begin to assess the effect of what I've done.

Picasso has to submit to a vision rather than dominate it. Penrose, discussing the accounts of people who have watched Picasso at work, makes a similar point: 'The line becomes visible in the exact place where it is required with such certainty that it is as though he were communing with a presence already there.' Like a spiritualist medium, Picasso submits to what wants to be said. And this is the measure of his dependence on some inspiration outside himself. He needs to identify himself with others.

In fact this is exactly what one would expect. The closer art is to magic, the less economically developed the social system that has nurtured it, the more likely it is that the artist will feel himself a spokesman, a seer for others. The artist who finds his subject within his own activity as an artist, did not exist before the end of the nineteenth century, and Cézanne is probably the prototype.

To understand something of the power for an artist of his self-identification with others, consider for a moment the case of the Negro poet Aimé Césaire. Césaire was born in Martinique in 1913. He studied at the École Normale in

136

Paris. In 1939 he published extracts from his long and great poem *Cahier d'un retour au pays natal*. But it was not until 1947 that the poem was published as a whole. In 1950 Picasso illustrated what was by then his fourth book of poems, called *Corps perdu*.

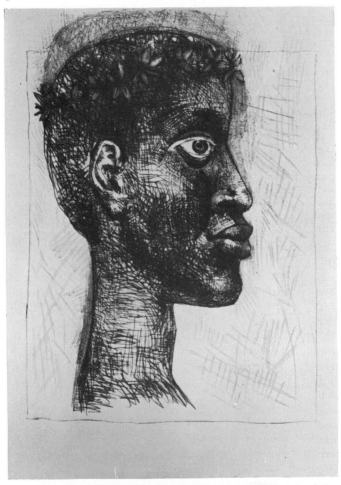

74 *Picasso. Illustration to Aimé Césaire's* Corps perdu. *1950*

Cesaire is an extremely sophisticated poet. His use of the French language can be compared with Rimbaud's. But the theme of his poetry is urgent and political: the theme of the struggle of all Negro peoples everywhere for equal

137

rights – economically, politically, and culturally. He has been a Deputy in the National Assembly in Paris, and the mayor of Fort-de-France, capital of Martinique.

In his poems he uses magic as a metaphor. He metaphorically turns himself into a magician so that he may speak for and to the Negro world at the deepest level of its experience and memories. But because he is not alone, there is no nostalgia in this 'regression', and certainly no idealization of the 'noble savage'. He claims humanity for his own people and accuses of savagery – without any nobility at all – those who exploit and repress them.

A true Copernican revolution must be imposed here [Africa], so much is rooted in Europe, and in all parties, in all spheres, from the extreme right to the extreme left, the habit of doing for us, the habit of thinking for us, in short the habit of contesting that right to initiative which is in essence the right to personality.

For Césaire there is no essential contrast (and for this reason no possibility of idealization) between the primitive and the highly developed. What lies between them is prevention and greed. Otherwise the progression from the simple to the complex would be as natural as in these lines:

> The wheel is the most beautiful discovery of man
> and the only one
> there is the sun which turns
> there is the earth which turns
> there is your face which turns
> upon the axle of your throat when you cry. . . .

Or, expressed more directly:

They demand of us: 'Choose . . . choose between loyalty and with it backwardness, or progress and rupture.' Our reply is that things are not so simple, that there isn't an alternative. That life (I say life and not abstract thought) does not know and does not accept this alternative. Or rather that if this alternative presents itself, it is life that will take care of its transcendence.

Like Picasso, Césaire reaches across history. Like Picasso he would have confounded everybody before the twentieth century, because it would have seemed impossible then for a man to be in two 'times' at once: in the heart of Africa and

at the centre of European literature. But, unlike Picasso's, Césaire's 'reach' is being constantly confirmed by events. He is part of a force that is changing the world before our eyes; whereas Picasso has become a law unto himself.

Here in the *Cahier d'un retour au pays natal*, Césaire imagines how it will be when he returns home:

I would find once more the secret of great speech and of great burning. I would say storm. I would say river. I would say tornado. I would say leaf, I would say tree. I would be soaked by each rain, moistened by every dew. As frenetic blood rolls upon the slow current of the eye, so I would roll words like maddened horses like new children like clotted milk like curfew like traces of a temple like precious stones far enough away to daunt all miners. Who could not understand me would no more understand the roaring of the tiger.

Rise, phantoms, chemical-blue from a forest of hunted beasts of twisted machines of jujube-tree of rotten flesh of a basket of oysters of eyes of a lacework of lashes cut from the lovely sisal of a human skin I would have words huge enough to contain you all and you too stretched earth drunken earth
earth great sex raised at the sun
earth great delirium of God
earth risen wild from the sea's locker with a bunch of cecrops in your mouth
earth whose surfing face I must compare to the mad and virgin forests that I would wish to wear as countenance before the undeciphering eyes of men.
one mouthful of your milk-spurt would let me discover always at the distance of a mirage an earth – a thousand times more native, golden with a sun no prism has sampled – a fraternal earth where all is free, my earth.

When Césaire arrives back in Martinique, he is disappointed. He finds an apathetic, demoralized, trivial colony:

Now I have come.
Once more this limping life before me, no not this life, this death, this death without sense or piety, this death where greatness pitifully fails, this death which limps from pettiness to pettiness; little greeds heaped on top of the conquistador; little flunkeys heaped on top of the great savage; little souls shovelled on top of the three-souled Caribbean.

Later he recovers from his disappointment, and pledges himself to his people, since it is only by such identification that the magic can be wrought, the magic of a 'fraternal earth'.

> And here at the end of the small hours is my virile
> prayer
> that I may hear neither laughter nor crying, my eyes
> upon this city which I prophesy as beautiful.
> Give me the sorcerer's savage faith'
> give my hands the power to mould
> give my soul the temper of the sword,
> I will stand firm. Make of my head a prow
> and of myself make neither a father,
> nor a brother, nor a son,
> but the father, but the brother, but the son,
> nor make of me a husband, but the lover of this
> unique people.

I quote Césaire at such length because today it is hard for most Western European intellectuals to imagine the devotion which an artist may feel for his 'unique people'. This devotion is the result of mutual dependence. The people need a spokesman – the fact that Césaire is a French Deputy is almost as important as his being a poet; the artist needs the clamour and hopes of those whom he represents.

For Picasso there has been no such 'unique people'. He has exiled himself from Spain. He has seldom left France, and in France he has lived like an emperor in his own private court. Such facts would not necessarily count if he could still have identified himself in imagination with a 'unique people'. But the unique people have been reduced to a unique person, who only half exists by virtue of his contrast with everybody else: the noble savage.

We must now return to the consequences of Picasso's isolation as they have affected his art. He has not lacked appreciation. Nor has he lacked creativity. What he has lacked are subjects.

When it comes to it, there are very few subjects. Everybody repeats them. Venus and Cupid becomes the Virgin and Child, then a Mother and Child, but it's always the same subject. To invent a new subject must be wonderful. Take Van Gogh. His potatoes – such an everyday thing. To have painted that – or his old boots! That was really something.

140

In this statement – it was part of a conversation with his old dealer Kahnweiler in 1955 – Picasso unwittingly reveals his difficulty. No other statement tells us so much about the fundamental problem of his art. Only in the crudest sense is a Venus and Cupid the same subject as a Virgin and Child. One might as well say that all landscapes from the early Italians to Monet are the same subject. The meaning of a Venus and Cupid, the significance of all that has been selected to be included in the picture, is totally different from that of a Virgin and Child, even when the latter is secular and has lost its religious conviction. The two subjects depend on an utterly different agreement being imagined between painter and spectator.

75

76

Compare these two paintings by Piero di Cosimo (1462–1521?), and in particular the central figure. In so far as she is the same woman with the same face, one could say that she is the same subject – no matter whether real or imaginary. Yet to say this is to *limit the whole concept of the subject to the relationship between the painter and the painted image*. It ignores what the painter is trying to say, and it dismisses the effect of the painting. The subject, instead of bringing into being or affirming an agreement between the painter and the spectator, is now reduced to a mere description of what the painter's hand is cataloguing. Such a view of what constitutes the subject of a work of art suggests a man so used to working alone that he has forgotten the possibility of agreement with anybody else. One is again reminded of the loneliness of a lunatic who, at the

75 *Piero di Cosimo. The Immaculate Conception*

76 *Piero di Cosimo. The Finding of Vulcan on Lemnos*

141

same time, is sane enough to know that it is useless to explain.

Certainly Van Gogh painted new subjects. But they were not 'inventions'. They were what he naturally found as a result of his self-identification with others. All new subjects have been introduced into painting in the same way. Bellini's nudes, Breughel's villages, Hogarth's prisons, Goya's tortures, Géricault's madhouse, Courbet's labourers – all have been the result of the artist identifying himself with those who had previously been ignored or dismissed. One can even go so far as to say that, in the last analysis, all their subjects are *given* to artists. Very few, such as he has been able to accept, have been given to Picasso. And this is his complaint.

When Picasso has found his subjects, he has produced a number of masterpieces. When he has not, he has produced paintings which eventually will be seen to be absurd. They are already absurd, but nobody has had the courage to say so for fear of encouraging the philistines for whom all art, because it is not a flattering looking-glass, is absurd.

Let me give some examples of when he has failed to find (or be given) his proper subject.

77 *Picasso.*
The Race.
1922

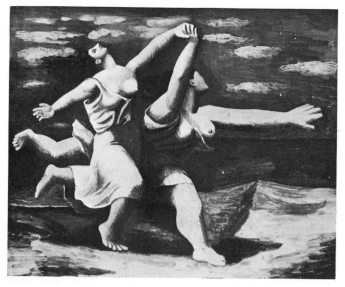

The Race was painted in Picasso's so-called Classic period. (Many artists went 'classic' at this time as if to forget the barbarism of the eight million dead of the war.) It was also the time, as we have seen, when Picasso was 'impersonating' various styles. There is to some extent a consciously absurd element in this painting. Yet where is the absurdity? Surely it lies in the fact that two such monumental giantesses are running so wildly, with such abandon. If, with their massive, formalized, marmoreal limbs, they are to be credible at all, they must be statuesque. By making them run like hares Picasso disconcertingly destroys their very *raison d'être*. The same thing happens stylistically: the figures are drawn with a kind of ponderous simplified logic of classical light-and-shade; yet the perspective which makes the nearest hand smallest and the farthest hand largest upturns that same logic and makes it absurd. There is also a similar reversal in emotional terms. Such figures are a caricature of all that is imperturbable, calm and timeless. Then suddenly they are set fleeing with an urgency that amounts to panic.

Perhaps this was precisely Picasso's intention, but I doubt it. He was impersonating; he was also interested in the Surrealists and their cult of the irrational; he probably wanted to make a picture that looked odd and was disturbing. But what he has achieved is a painting that cancels itself. It is true that at first it communicates a kind of shock – but this shock, by its very nature, precludes its communicating anything else. It is like seeing a candle blow itself out.

Because we know how directly and unintellectually Picasso works, it seems very unlikely that this was his real aim. And it seems far more likely that, having these monumental giantesses in his head (he had been painting them for two years), he tried to say something with them which they weren't capable of 'containing'. And thus his purpose or the compulsion of his feelings destroyed his subject because it was the wrong one.

In the 1927 *Figure*, it seems that the subject (a nude woman) has been so destroyed that it is no longer identifiable. Yet if one goes on looking, one finds the clues – the tiny pin-head at the top, the arm going up to it, the breast and nipple displaced towards the bottom right, the mouth

of the vagina, like a cut, almost in the centre of the picture.
Although superficially the picture may look like a Cubist
collage, there is no interest here in structure or the dimen-
sions of time and space; it is obsessionally, impatiently
sexual. But its sexuality is without a subject. It is as though
this picture were crying out for a Leda and the Swan, or
a Nymph and Shepherd, or a Venus, to be given a form.
But there is nobody to call that form into being, nobody to
name it and separate it from Picasso by believing in it. What
Picasso is expressing here becomes absurd because there is
nothing *to resist him*: neither the subject, nor his awareness
of reality as understood by others. Without such resistance

144

the whole of Shakespeare's *Lear* would be no more than a
death-rattle.

The *Woman in an Arm-chair* is less distorted. Nobody
can fail to see that this represents a woman. People may
pretend to themselves that they can't disentangle the figure,
because it constitutes such a violent attack on their sense of
propriety; but recognizing the attack, they also recognize the
figure. Nevertheless, the painting is as absurd as the last

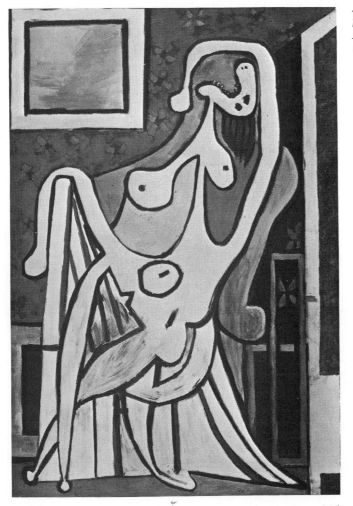

79 *Picasso.*
Woman in an
Arm-chair.
1929

one, and the subject has again been destroyed – although in a different way. The motive of the painting is no longer straightforwardly sexual, but far more bitterly and desperately emotional. It is for this reason that the physical displacements of the body are far less extreme, but the overall effect more violent. There is no Venus behind this picture; rather one of the Seven Deadly Sins, feared, resented, and yet undismissible. It is absurd because, removed from the medieval context of Heaven and Hell, the violence of the emotion conveyed and yet not explained and not related to anything else, destroys our belief in the subject. It is perfectly possible to believe that Picasso felt like that, but we cannot share this feeling with him because it cannot be understood or evaluated on the evidence of what he shows us. We have no way of telling whether it is noble anger or petulance. All we can recognize is that *he* is disturbed. What disturbed him we do not know – because he has not been able to find the subject to contain his emotion.

80 Picasso.
Girls with a
Toy Boat.
1937

In *Girls with a Toy Boat* the problem is different. It isn't now a question of Picasso being driven by a feeling or emotion which he cannot house in a subject; here he gives himself up to his own ingenuity, and the absurdity arises

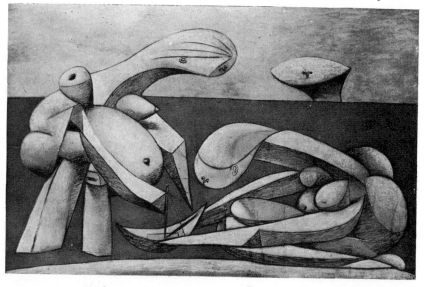

because he appears to *ignore* the emotive power of the forms with which he is playing. He is planning a new (and momentary) human anatomy, as schoolboys plan rockets or perpetual-motion machines. His method of drawing is very precise and three-dimensional, so that it would be quite easy to construct one of these figures out of wood or paper. This tangibility increases the absurdity. Such 'real' breasts, buttocks, and stomachs attached to such machines are bound to make us laugh in order to release the tension of the emotion provoked by the sexually charged parts and then belied by all the rest. A similar inconsistency is implied by the action. If they are children playing with a boat, why have they women's bodies? If they are women, why the toy boat? It may seem naïve to ask such a logical question of a painting in which a head can peer over the horizon as though over the edge of a table. Of course Picasso was joking, trying to shock, playing at contradictions. But this was because he didn't know what else to do. And the comparatively untransformed sexual parts, so inconsistent with the rest, are an indication of this indecision. Within three months of painting this picture, he was painting *Guernica*; it is worth comparing these figures with one of the figures there.

81 *Picasso.*
Guernica
(*detail*). *1937*

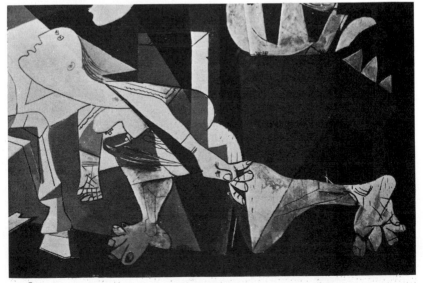

147

Every part of the body of the woman in *Guernica* contributes to the same end; her hands, her trailing leg, her twisted buttocks, her sharp nipples, her craning head – all bear witness to what at this moment is her single ability: the ability to suffer pain. The contrast between the two paintings is extraordinary. Yet in many ways the figures are similar, and without the exercise of paintings like *Girls with a Toy Boat* Picasso would never have painted *Guernica* in the way he did. The difference is one of single-mindedness. Yet to be single-minded you have to know what you want. And for Picasso to know what he wants, he has first to find his subject.

82 Picasso.
Nude
Dressing her
Hair. 1940

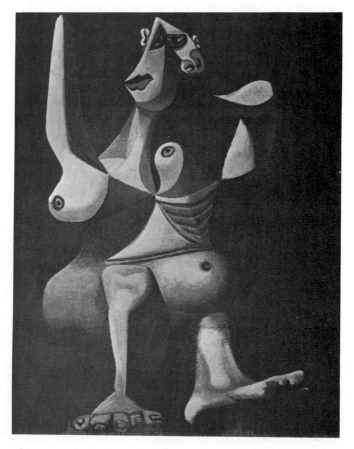

Picasso painted the 1940 nude immediately after the defeat of France, whilst the German troops were occupying Royan, on the Atlantic coast, where he had fled. It is an anguished painting, and if one knows of the circumstances in which it was painted, it becomes an understandable picture. But it remains absurd, even if horrifically absurd. To see why this is so, let us again make a comparison with a successful painting. Both pictures are the result of the same experience – the experience of defeat, occupation, and a terrible vision of evil, which was in no sense metaphysical, but there in the streets in its jackboots and with its swastika.

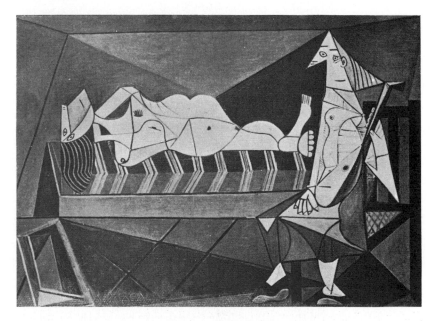

This second picture, painted two years later, is no more explicit about the general experience from which it derives, but it is self-contained and consistent. The experience has found a subject. The subject, baldly described in words, may seem unremarkable: a woman on a bed and another woman sitting on a chair, holding a mandolin which she is not playing. Yet in the relationship between these two women and the furniture and the room that closes in around

83 *Picasso.*
Nude with
a Musician.
1942

149

them, without a window or a door, there is all the claustro-phobia of the curfew and a city without freedom. It is like making love in a cell where there is never any daylight. It is as though the sex of the woman on the bed and the music of the mandolin had been deprived of all their resonance, because such resonance requires a minimum freedom within which to vibrate. The real subject is not simply the two women, but *the state of being confined in this room*. In Picasso's mind, as he painted it, there must have been an image of such a room, an image of curfew, to which he could refer and through which he could express his emotion.

The *Nude Dressing her Hair* squats in an even more cell-like room. But because there is no consistency between the parts (just as was the case with the *Toy Boat*) we are unable to accept the scene as a self-contained whole. None of the parts refers to each other: instead, each, separately, refers to us, and we then refer it back to Picasso. A normal mouth forms part of a slashed, displaced face. The underneath of a foot, seen as by a chiropodist, joins on to a butcher's bone which ends in a stone stomach. It is true that the figure as a whole does pose one question: Is this a woman or a trussed fowl? And from that question we can deduce bestial in-dignities. But the question remains, as it were, rhetorical. We do not believe in the woman being a trussed fowl, we believe only in Picasso wanting to make her look like that. In the end we are left face to face with what seems to be Picasso's wilfulness. And it seems thus because he has not been able to express himself, because he has not been able to include his emotion in his subject but only impose his emotion upon it.

Some may see the difference between these two paintings as principally one of style. In the *Nude with a Musician* there is stylistic consistency. The way an eye is rendered is compatible with the way a hand, a foot, or hair is rendered. All are equidistant from (photographic) appearances. In the other painting there is deliberate stylistic inconsistency. Yet the true difference is more profound than this. We can imaginatively enter the first picture and as we proceed, moving from one part to another, we gather emotion. In front of the *Nude Dressing her Hair*, we never get beyond the violence that each part does to the next. No emotion

develops because it is short-circuited by shock. And that is exactly what happened when Picasso was painting it; he short-circuited his own emotion, because he could find no circuit for it through a subject. A woman's body by itself cannot be made to express all the horrors of fascism. But Picasso clung to this subject because, at that moment of fear and crisis, it was the only one of which he felt certain. It is the earliest subject in art, and modern Europe had failed to give him any other.

All that we have noticed about inconsistencies in the *Nude Dressing her Hair* applies equally to *First Steps*. Again this painting does no more than confront us with the

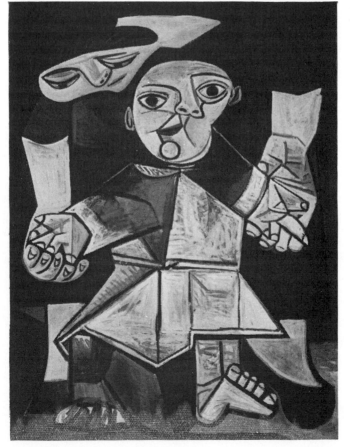

84 *Picasso.*
First Steps.
1943

151

evidence of Picasso's apparent wilfulness. But this time with far less reason, for the emotional charge is much smaller. It is not now a *cri de cœur* which tragically fails to achieve art, but mannerism.

The experience is Picasso's experience of his own way of painting. It is like an actor being fascinated by the sound of his own voice or the look of his own actions. Self-consciousness is necessary for all artists, but this is the vanity of self-consciousness. It is a form of narcissism: it is the beginning of Picasso impersonating himself. When we look at the *Nude Dressing her Hair* we are at least made to feel shock. Here we only become aware of the way in which the picture is painted – and this can be called clever or perverse according to taste.

It would be petty to draw attention to such a failure if it was incidental. What artist has not sometimes been vain

85 Picasso. Portrait of Mrs H. P. 1952

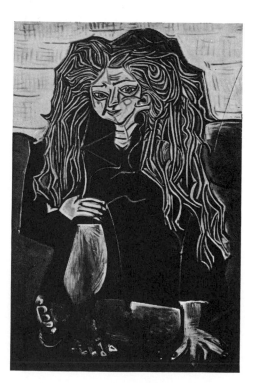

or self-indulgent? But later, after 1945, a great deal of Picasso's work became mannered. And at the root-cause of this mannerism there is still the same problem: the lack of subjects – so that the artist's own art becomes his subject. The *Portrait of Mrs H. P.* is a typical later example. The style is different, but not the degree of mannerism. So much is happening in terms of painting – the hair like a maelstrom, the legs and the hand painted fast and furiously, the face with its strange, abrupt hieroglyphs of expression – but what does it all add up to? What does it tell us about the sitter except that she has long hair? What is all the drama about? Unhappily, it is about *being painted by Picasso*. And that is the extremity of mannerism, the extremity of a genius who has nothing to which to apply himself.

To show how much a dramatically painted portrait can say, let me quote, without comment, a portrait by Van Gogh.

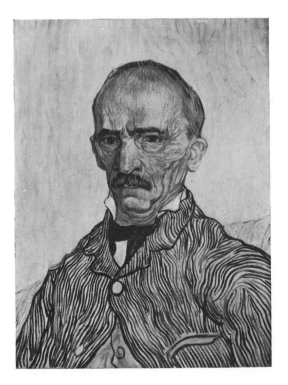

86 *Van Gogh.*
Portrait of the Chief Super-intendent of the Asylum at Saint-Remy.
1889

On the evidence of seven paintings I have tried to show you how, from about 1920 onwards, Picasso has sometimes failed to find subjects with which to express himself, and how, when this happens, he virtually destroys the nominal subject he has taken, and so makes the whole painting absurd. There are other paintings in which this has happened. There are even more in which it has partially happened. There are also paintings in which he has found his subject.

It would be as stupid to deny the originality of Picasso's failures as to pretend that this originality transforms them into masterpieces. Picasso is unique but, since he is a man and not a god, it is our responsibility to judge the value of this uniqueness.

It is not my intention to draw up a definitive list of Picasso's failures as opposed to his masterpieces. What I hope I have shown is the relevance of asking a particular question about Picasso. The question, I believe, leads to a standard by which all his work can usefully be judged.

Apart from the Cubist years, nearly all Picasso's most successful paintings belong to the period from 1931 to 1942 or 43. During this decade he at one moment – in 1935 – gave up painting altogether. It was a time of great inner stress. But it was also the period when he most successfully found his subjects. These subjects were related to two profound personal experiences: a passionate love affair, and the triumph of fascism first in Spain and then in Europe.

In the countless books about Picasso no secret is ever made of his many love affairs; indeed they have become part of the legend. Only one affair is passed over quickly – and that is the one to which I now refer. It is typical of the lack of realism which surrounds Picasso's reputation that this should be the case. There is no need to pry into his private life – even though this is so often and tastelessly described by his friends; but one fact has to be noted, because it is so directly related to his art. On the evidence of his paintings, his sculpture, and hundreds of drawings in sketchbooks, the sexually most important affair of his life was with Marie-Thérèse Walter whom he first met in 1931. He has painted and drawn no other woman in the same way, and no other

woman half as many times. It may be that she became a
kind of symbol for him, and that in time the idea of her
meant more to him than she herself. It may be that in the
full sense of the word he was more devoted to other women.
I do not know. But there is not the slightest doubt that for
eight years he was haunted by her – if one can use a word

87 *Picasso.*
Nude on a
Black Couch.
1932

88 *Picasso.*
The Mirror.
1932

155

normally applied to spirits to refer to somebody whose
body was so alive for him.

Today, among the five hundred or more of his own past
paintings which Picasso owns, over fifty are of Marie-
Thérèse. No other person dominates his collection a quarter
as much. When he paints her, her subject is always able to
withstand the pressure of his way of painting. This is
because he is single-minded about her, and can see her as
the most direct manifestation of his own feelings. He paints
her like a Venus, but a Venus such as nobody else has ever
painted.

What makes these paintings different is the degree of
their direct sexuality. They refer without any ambiguity
at all to the experience of making love to this woman. They
describe sensations and, above all, the sensation of sexual
comfort. Even when she is dressed or with her daughter
(the daughter of Marie-Thérèse and Picasso was born in
1935) she is seen in the same way: soft as a cloud, easy, full
of precise pleasures, and inexhaustible because alive and
sentient. In literature the thrall which a particular woman's
body can have over a man has been described often. But
words are abstract and can hide as much as they state. A
visual image can reveal far more naturally the sweet
mechanism of sex. One need only think of a drawing of a

breast and then compare it to all the stray associations of the word, to see how this is so. At its most fundamental there aren't any words for sex – only noises: yet there are shapes. The old masters recognized this advantage of the visual. Most paintings have a far greater sexual content than is generally admitted. But when the subjects have been undisguisedly sexual, they have always in the past been placed in a social or moral perspective. All the great nudes imply a way of living. They are invitations to a particular philosophic view. They are comments on marriage, having mistresses, luxury, the golden age, or the joys of seduction. This is as true of a Giorgione as of a Renoir. The women lie there like conditional promises. The subjective experience of sex – the experience of the fulfilling of the promise – is ignored. (And ignored most pointedly of all in 'pornographic' pictures illustrating the sexual act.)

It is understandable that this should have been so in the past. There were stricter religious and social taboos. There was greater economic dependence of women and therefore a greater emphasis on the conventions of chastity and modesty. There was an established public role of art. A painting was painted for somebody else, so that 'auto-biographical' painting was very rare; the subjective experience of sex can only be expressed autobiographically. There were also stylistic limitations.

The painter's right to displace the parts – the right which Cubism won – is essential for creating a visual image that can correspond to sexual experience. Whatever the initial stimuli of appearances, sex itself defies them. It is both brighter and heavier than appearances, and finally it abandons both scale and identity.

These Picassos are, in a sense, nearer to drawings on lavatory walls than to the great nudes of the past. (Again, I am aware of giving arguments to the philistines, but I can scarcely believe that it matters any more – and philistinism anyway can never be argued with.) They are nearer to *graffiti* because they are so single-mindedly about making love. But they differ most profoundly from most *graffiti* in that they are tender instead of aggressive. The crudity of the average wall-drawing is not simply the result of a lack of skill. Such drawings are nearly always a protest against deprivation: an expression of frustration. And within this

frustration there is both desire and resentment. Thus the crudeness of the drawings is also a way of insulting the sex that has been denied. The Picassos, by contrast, praise the sex they have enjoyed. Here for everybody to recognize are William Blake's 'lineaments of satisfied desire'.

90 *Picasso.*
Nude. 1933

It is no longer possible to say whether these 'lineaments' are an expression of Picasso's pleasure in the woman's body, or a description of her pleasure. The paintings, because they describe sensation, are highly subjective, but part of the very force of sex lies in the fact that *its subjectivity is mutual.* In these paintings Picasso is no more just himself: he is the two of them, and their shared subjectivity includes in some part or another the experience of all lovers.

158

In a sculpture of the same period this shared subjectivity becomes the underlying theme of the work.

Picasso made several variations of this head and it is the same head which appears in his etchings of the artist in his studio. It is identified with Marie-Thérèse, but is by no means a portrait. In the etchings it stands there in the

studio like a silent oracle, looking at the sculptor and his
model who are lovers.

92 *Picasso.*
Sculptor and
Model
Resting.
1933

Its secret is a metaphor. It represents a face. Yet this face
is reduced to two features: the nose, rounded and powerful,
which thrusts forward and is simultaneously heavy and
buoyant; and below it, the mouth, soft, open, and very
deeply modelled. In terms of the density of their implied
substance, the nose is like wood and the mouth like earth.
These two features emerge from three rounded forms
which have been formalized from the cheeks and the bun
of hair at the back of the head. The scale of the work is
what first offers a clue to the metaphor. It is very much
larger than a head – one stands looking at it as at a figure,
a torso. Then one sees. The nose and the mouth are meta-
phors for the male and female sexual organs; the rounded
forms for buttocks and thighs. This face, or head, embodies
the sexual experience of two lovers, its eyes engraved upon
their legs. What image could better express the shared
subjectivity which sex allows than the smile of such a face?
 Picasso may have arrived at the metaphor unconsciously.
But afterwards he deliberately played with the idea of
transforming a head into sexually charged component

160

parts. One can see the process at work in a sequence of drawings like this:

Perhaps the same reference also applies to some of the desperately bitter heads of the early forties. Like the *Nude with a Musician* (but less successfully) they too are paintings about a hateful impotence.

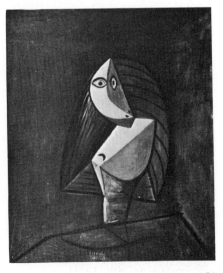

It is as though – and here Picasso is like most of us – he can only fully see himself when he is reflected in a woman. And it is as though – and here he is rarer – it is almost only through the marvellous shared subjectivity of sex that he can allow himself to be known. The majority of his paintings are of women. There are surprisingly few men. A number of the women are portrayed as themselves. Others are idealizations. But most of them are composite creatures – themselves and he together. In a sense these paintings might be called self-portraits – not portraits of himself alone and untransformed, but self-portraits of the creature he and the woman became as they sensed one another. The relationship is always sexual but the pre-occupations of the composite creature may not be. It is when this happens that the painting becomes absurd and destroys itself – as was the case with the *Nude Dressing her Hair*. Shared subjectivity can no longer exist except when the aim is sex. It becomes instead a form of megalomania.

Thus, on a psychological level, the problem is a similar one to that of finding a subject, of finding the apt vehicle for self-expression. Picasso finds himself in women – and the fact that he has otherwise been so isolated must have increased this need. Through himself, found in woman, he then tries to say things as an artist. Sometimes these things are unsayable because they are essentially outside the scope of the relationship. When they are about the essence of that relationship, when the shared subjectivity that Picasso needs is actually created by sex, then the results are purer and simpler and more expressive than any comparable works in the history of European art. Other works may be more subtle because they deal with the social complexities of sexual relations. Picasso abstracts sex from society – there is no hint in the bronze head or *The Nude on a Black Couch* of the role of a mistress, the happiness of marriage, or the attraction of *les fleurs du mal*. He returns sex to nature where *it becomes complete in itself*. This is not the whole truth but it is an aspect of the truth of which no other painter has had the means or courage or simplicity to remind us.

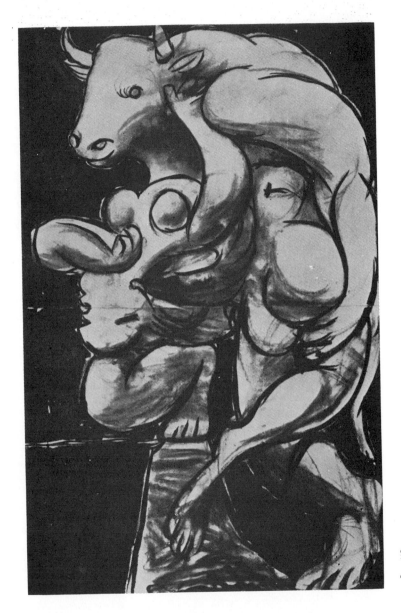

95 *Picasso.*
Young Girl
and Minotaur.
1934–5

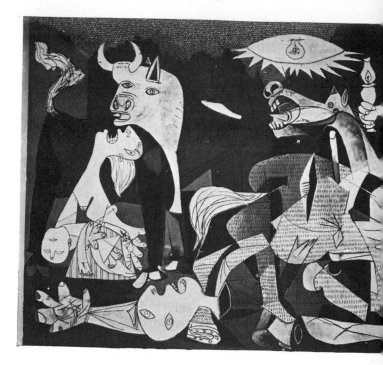

On 26 April 1937 the Basque town of Guernica (population 10,000) was destroyed by German bombers flying for General Franco. Here is the report from *The Times:*

Guernica, the most ancient town of the Basques and the centre of their cultural tradition, was completely destroyed yesterday afternoon by insurgent air-raiders. The bombardment of the open town far behind the lines occupied precisely three hours and a quarter, during which a powerful fleet of aeroplanes consisting of three German types, Junkers and Heinkel bombers and Heinkel fighters, did not cease unloading on the town bombs weighing from 1,000 lb. downwards. . . . The fighters meanwhile flew low from above the centre of the town to machine-gun those of the civilians who had taken refuge in the fields. The whole of Guernica was soon in flames except the historic Casa de Juntas. . . .

In less than a week Picasso began his painting. He had already been commissioned by the Spanish Republican Government to paint a mural for the Paris World Fair.

164

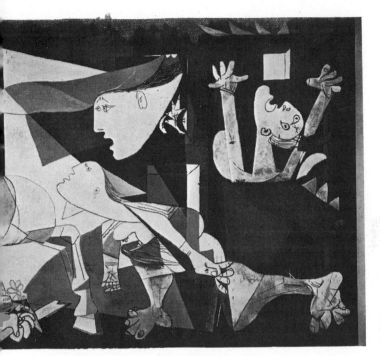

96 *Picasso.*
Guernica.
1937

In June the painting was installed in the Spanish building there. It immediately provoked controversy. Many on the left criticized it for being obscure. The right attacked it in self-defence. But the painting quickly became legendary and has remained so. It is the most famous painting of the twentieth century. It is thought of as a continuous protest against the brutality of fascism in particular and modern war in general.

How true is this? How much applies to the actual painting, and how much is the result of what happened after it was painted?

Undoubtedly the significance of the painting has been increased (and perhaps even changed) by later developments. Picasso painted it urgently and quickly in response to a particular event. That event led to others – some of which nobody could foresee at the time. The German and Italian forces, who in 1937 ensured Franco's victory, were within three years to have all Europe at their mercy.

165

Guernica was the first town ever bombed in order to intimidate a civilian population: Hiroshima was bombed according to the same calculation.

Thus, Picasso's personal protest at a comparatively small incident in his own country afterwards acquired a world-wide significance. For many millions of people now, the name of Guernica accuses all war criminals. Yet *Guernica* is not a painting about modern war in any objective sense of the term. Look at it beside David Siqueiros's *Echo of a Scream*, also painted in 1937 and suggested, I suspect, by a picture of a child screaming in a Spanish Civil War newsreel.

97 *Siqueiros.*
Echo of a
Scream. 1937

166

In the Siqueiros we see the materials which make modern war possible, and the specific kind of desolation to which it leads. By contrast, the Picasso might be a protest against a massacre of the innocents at any time. Picasso himself has called the painting an allegory – but has not fully explained the symbols he has used. This is probably because they have too many meanings for him.

Three years earlier Picasso made an etching of *Bull, Horse, and Female Matador*, which, in imagery, is very similar to *Guernica*. But here the matador is Marie-Thérèse, and the meaning of the scene is wholly concentrated on the movable frontier between sexual urgency and

98 *Picasso. Bull, Horse, and Female Matador.*
1934

violence, between compliance and victimization, pleasure and pain. That is not to suggest that it is complicated in anything but a sensuous way. It is the body, not the mind, that submits to a kind of death in sex, and an awareness, after love, of feminine vulnerability is the result of an instinctual impulse – an impulse which man shares with many animals.

When Picasso painted *Guernica* he used the private imagery which was already in his mind and which he had been applying to an apparently very different theme. But only apparently – or anyway, only superficially different. For *Guernica* is a painting about how Picasso *imagines* suffering; and just as when he is working on a painting or sculpture about making love the intensity of his sensations makes it impossible for him to distinguish between himself

99 *Picasso.*
Crying
Woman. 1937

and his lover, just as his portraits of women are often self-portraits of himself found in them, so here in *Guernica* he is painting his own suffering as he daily hears the news from his own country.

The etching the *Crying Woman* (which is part of the whole cycle of works connected with *Guernica*) is no longer a directly sexual metaphor, but it is nevertheless the tragic complement to the giant bronze head. It is a face whose sensuality, whose ability to be enjoyed, has been blown to pieces, leaving only the debris of pain: It is not a moralist's work but a lover's. No moralist would see the pain so self-destructively. But for the lover, there is still a shared subjectivity. What has happened to this woman's face is like a castration.

Guernica, then, is a profoundly subjective work – and it is from this that its power derives. Picasso did not try to imagine the actual event. There is no town, no aeroplanes, no explosion, no reference to the time of day, the year, the century, or the part of Spain where it happened. There are no enemies to accuse. There is no heroism. And yet the work is a protest – and one would know this even if one knew nothing of its history. Where is the protest then?

It is in what has happened to the bodies – to the hands, the soles of the feet, the horse's tongue, the mother's breasts, the eyes in the head. What has happened to them *in being painted* is the imaginative equivalent of what happened to them in sensation in the flesh. We are made to feel their pain with our eyes. And pain is the protest of the body.

Just as Picasso abstracts sex from society and returns it to nature, so here he abstracts pain and fear from history and returns them to a protesting nature. All the great prosecuting paintings of the past have appealed to a higher judge – either divine or human. Picasso appeals to nothing more elevated than our instinct for survival. Yet this appeal now confirms the most sophisticated assessment of the realities of the modern world, which the political leaders of both the East and the West have been obliged to accept.

The successful pictures that Picasso painted after *Guernica* act at the same level of experience: a level of intense physical subjectivity. There are the still-lifes of animal

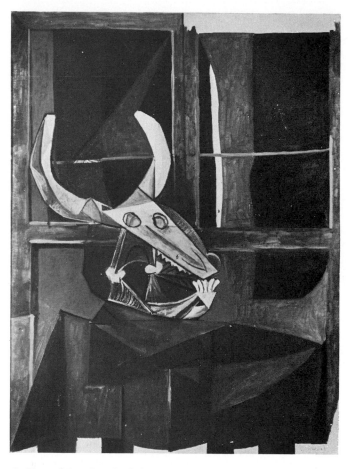

100 *Picasso.*
Still-life
with Bull's
Skull. *1942*

skulls and heads which he painted during the first years of
the German occupation. These are really further studies of
the agonized horse's head in *Guernica*. They are tragedies
of the flesh. The difference is that everything now is still
and silent.

The major work after *Guernica* is the *Nude with a
Musician* which we have already examined. But now we can
see how it is related to the nudes of Marie-Thérèse. It is all
that they are not. It is their lament. The body of the
woman on the bed is the loss of all their pleasure. No
traditional contrast between youth and age is half so pointed
because there the differences are objective – the breasts

170

shrink, the back bends; here the contrast is subjective too. Once more it is impossible to distinguish between the joy-lessness of her body and his joylessness in her. What they both experience now is deprivation. It is a painting about the physical sensation of absence. Whether the absence is of freedom, of food, of passion, of hope, or of the other person, is not important – and for Picasso it may again have had so many meanings that he himself could not have explained it further.

By 1943 the second and last great period of Picasso's life as an artist had ended. During that period he had painted some bad pictures but he had also painted some great ones. After 1943 he produced nothing comparable. Why could he not go on as before? Picasso's great paintings from 1931 to 1943 were all, including *Guernica* – and that is where so many critics have been misled – autobiographical. They were confessions of highly personal and very immediate experiences. They embody no social imagination in the usual modern sense of the word. The first paintings were about sexual pleasure; the tragic paintings of Guernica and the war were about pain and were the obverse of the erotic paintings. All of them were concerned with express-ing sensations. All of them exploited the freedom to dis-place parts – the freedom won by Cubism – to achieve their aim.

To find these subjects Picasso scarcely had to leave his own body. It is through the experience of his own body that he painted erotic pictures, and it is through his own physical imagination, heightened by sexual experience, that he painted the war pictures. (It is interesting to note that in the latter almost all the figures are women.) The choice of his successful subjects was limited to what was happening to him at a very basic level. At that level – a level which no European painter had ever before investi-gated so deeply – the special significance or meaning of a subject is biologically rather than culturally assured. At that level – if we have the courage to admit it – we are all one.

To have continued painting like this would have meant continuing to live as intensely and eventfully as during the last decade. At the age of sixty-two this was probably

impossible. But anyway it was not something which could be willed or chosen. The affair with Marie-Thérèse was over, and, although other women took her place, the same passions were not involved. The Spanish War was ended and nothing again was likely to possess Picasso like the news of that civil war in his own country had done. The Nazis were being beaten at Stalingrad: in a year Paris was to be liberated. Partly because of his age, partly because of the course of world events, it was no longer possible for Picasso to feel that the initiatives remained with him. He saw and imagined the experiences of others as being more intense and more significant than his own. He had to discount his own body – and with it, its subjects.

There were also positive reasons why Picasso may have wanted at this time to begin a new phase of his working life. Having lived through the occupation and so experienced political events at first hand, as he had not done since his youth in Spain, he was genuinely moved by political emotions. Most of his friends were in the Resistance, and he himself, although he took no part, nevertheless became a figure-head of the movement. When at last Europe was liberated, he felt – like millions of others – that he must assist the birth of a new world. And in 1944 he joined the French Communist Party.

This was a moment of truth which it had taken him fifty years to arrive at. It was the moment when Picasso acted and chose so as to come to terms with both the reality around him and his own genius.

Ever since Picasso first arrived in Western Europe he had been critical of what he saw. Except for the Cubist years, when he was under the influence of others, his criticisms were expressed by his repeatedly shown preference for the primitive. Like Rousseau, he opposed nature to society. Such a 'revolutionary' attitude, valid a hundred and fifty years ago, is now outdated. Revolutionary philosophy today is materialist, and the only revolutionaries really feared by capitalism are marxists. And so, by joining the Communist Party, Picasso for the first time made his revolutionary feelings effective in terms of modern reality.

Picasso's genius is of a type that requires inspiration from other people. He is a spokesman or seer for others. He is in no sense the solitary modern investigator, for he hasn't

172

sufficient faith in reason or progress in art. Denied such inspiration by the milieux in which he moved after 1914, he often failed to find subjects to contain his emotions. At the same time he was forced to search within himself for an equivalent inspiration. To some extent he found it by idealizing his *alter ego* as a 'noble savage'. During the thirties and early forties this ambiguous contract within himself allowed him to create some highly original masterpieces: paintings in which, with all his skill and sophistication as an artist, he acts as a spokesman for his own instinctual experiences. But this could not continue indefinitely, for it was too inverted. He needed inspiration from those to whom he could belong, rather than from what, inevitably, belonged to him. He needed what Aimé Césaire calls his 'unique people'. By joining the Communist Party this is what he hoped to find. If he found it, his genius would be released as never before.

Explaining his decision, he spoke as follows:

Have not the Communists been the bravest in France, in the Soviet Union, and in my own Spain? How could I have hesitated? The fear to commit myself? But on the contrary I have never felt freer, never felt more complete. And then I have been so impatient to find a country again: I have always been an exile, now I am no longer one: whilst waiting for Spain to be able to welcome me back, the French Communist Party have opened their arms to me, and I have found there all whom I respect most, the greatest thinkers, the greatest poets, and all the faces of the Resistance fighters in Paris whom I saw and were so beautiful during those August days; again I am among my brothers.

'I have never felt more complete.' This may have been a rhetorical phrase, but I doubt it. Everything we have so far argued in this essay suggests that it was the truth.

It is hard to say for certain whether Picasso's hopes were justified or not. Was he disappointed or was he betrayed? It is a question which communist intellectuals, and especially French ones, might well ask themselves. None do, for none see for what it is the waste of the last twenty years of Picasso's working life.

On the face of it, it might seem unreasonable to hope that the mere act of joining a political party could resolve the

173

contradictions of a lifetime. But it *is* reasonable to expect that a communist party is unlike any other. It is more than a political party. It is a school of philosophy, an army, an agent of the future; at its noblest it is a fraternity. Communist parties have helped to create artists – and, tragically, have also destroyed artists. They helped to create Mayakovsky, Eisenstein, Brecht, Éluard. Perhaps a communist party could have sustained Picasso. One should

101 *Picasso.*
Dove (poster)

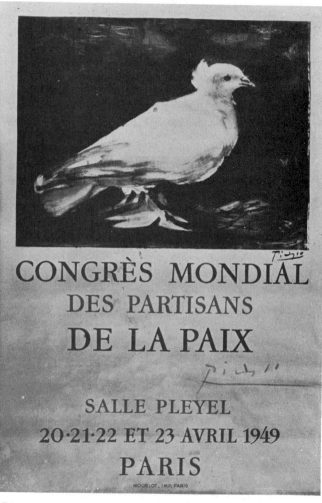

CONGRÈS MONDIAL
DES PARTISANS
DE LA PAIX

SALLE PLEYEL
20·21·22 ET 23 AVRIL 1949
PARIS

MOURLOT_IMP. PARIS

remember that his whole life experience had rendered him at that moment open to help. 'I have found there all whom I respect most . . . again I am among my brothers.'

Whatever might have been the result of the communists serving Picasso better, the thing which is quite certain is that they served him badly. He asked for bread (such as perhaps they could not have supplied), but without any doubt what they offered him was a stone.

As a result of Picasso's joining the Communist Party and taking part in the peace movement, his fame spread even wider than before. His name was quoted in all the socialist countries. His poster of the peace dove was seen on millions of walls and expressed the hopes of all but a handful of the people of the world. The dove became a true symbol: not so much as a result of Picasso's power as an artist (the drawing of the dove is evocative but superficial), but rather as a result of the power of the movement which Picasso was serving. It needed a symbol and it claimed Picasso's drawing.

That this happened is something of which Picasso can be rightly proud. He contributed positively to the most important struggle of our time. He made further posters and drawings. He lent his name and reputation again and again to encourage others to protest against the threat of nuclear war. He was in a position to use his art as a means of influencing people politically, and, in so far as he was able, he chose to do this consciously and intelligently. I cannot believe that he was in any way mistaken or that he chose the wrong political path. But as an artist with all his powers he was nevertheless wasted.

In becoming a communist, Picasso hoped to come out of 'exile'. In fact the communists treated him as everybody else had done. That is to say they separated the man from his work. They honoured the former and equivocated about the latter. He had communist friends – such as Éluard – who really admired his painting. I speak of the world Communist movement as a whole because Picasso was by now a world figure.

In Moscow his reputation as a great man was used for propaganda purposes – whilst his art was dismissed as decadent. His paintings were never shown. No book was published on his work – not even one setting out to prove the alleged decadence. Like the life story of the black

sheep in a bourgeois family, his art became unmentionable. Remaining unmentionable, it acquired for some a false glamour. On no side was there any attempt at analysis.

Outside the Soviet Union it was little better. Because of Soviet insistence at that time on a universal cultural orthodoxy, Communist critics and artists in Western Europe who approved of Picasso's work spent their energy trying to stretch the orthodox vocabulary to cover as many paintings as possible. It wasn't, now, that his art was unmentionable but that it could only be mentioned in conventionalized terms. Gradually a disguise for Picasso was stitched together out of words. His spirit as an artist was celebrated in terms so basic and so 'human' that they could cause no offence to anybody, and these terms, these clichés became, instead of the paintings themselves, the currency of exchange on the subject of Picasso amongst the European communist left. Such clichés also precluded analysis or criticism.

Here is an example of the disguise being applied. Aragon is an extremely gifted writer. But here, in his role as cultural impresario of the left, his very quality of imagination rings false. Probably he convinced himself that everything was as fine and simple as he suggests, but at heart he must have known it was not so. He wanted to defend Picasso from the philistinism of Zhdanov in Moscow. Yet in defending him in this kind of way, he did Picasso no service.

In this exhibition . . . a man of 1950 has wanted to show his work, the seriousness of his work – even when it escapes them – to other men of 1950. And there is no doubt that those men, with their prejudices, their understandable demands, some of them with their deep-rooted need to hate or to snigger, others with their simple surprise and their *respectworthy* bewilderment, there is no doubt that they will stop in front of this series of pictures where the black and the white, better than all the colours of day, make up the light of a room of which we shall never know more than the edge of a curtain, the slats of the blinds, the side of a mattress; and yet there they all are, the sceptic, the partisan, the bewildered one, the woman with her child on her arm, the soldier as yet a little unfamiliar with the arms he bears, the older man, the man with the ready laugh – there we are, all of us, we have come into the room with Picasso and hush! we hold our breath, our voices, our steps. In this room, a

176

woman is watching a man asleep. The variations of a theme taken up a hundred times by the painter, here limited to a few drawings, converge towards a drawing where the woman – the one in the foreground – watches another woman, crouching like herself, as though she were looking at herself in a mirror.

At this point of our visit, which of us would raise his voice? Here we are, different yet alike, led as though by the hand into the very heart of the intimate life of men, face to face with a spectacle so beautiful that we must go back to the masters of colour, to the Venetian painters, in order to explain our astonishment to ourselves.

It was as though Picasso could do no wrong, because whatever he did was never examined. Because he was the most famous artist in the world *and* a communist, he was exempt. Exemption is very like exile. One faction called this exemption 'decadence': the other 'eternal hope'. As we have seen, Picasso needed subjects. Yet what the communist movement offered him back was only the exhausted subject of himself. Picasso as Picasso as Picasso.

Could it have been otherwise? It is usually a waste of time to play historical 'if onlys'. But in this case the alternative is perhaps relevant because similar mistakes are still being made. Official Soviet art policy is so dangerously wrong-headed not because it has enshrined within the Soviet Union a style of naturalism which originated with the bourgeois *nouveaux riches* of the nineteenth century (its only appeal is the desire for *owning* the subject) – this could right itself; the disastrous part is to believe that such a style is exclusively and universally the style of socialist art, for this allows provincial prejudice to oust reason and forces the very special limitations of Russian art history on art everywhere. It shrinks the whole vast subject, and with half an answer begs every question.

The French attitude to art would seem to be very different from the Russian. Yet today there is one characteristic in common: a provincial complacency. Because Paris was for so long the art centre of the world and because the art trade in Paris has grown until it is now one of the 'industries' of the city, it has become an accepted idea amongst nearly all French intellectuals, including communists, that art is the natural blessing of France.

177

They are not so naïve as to believe that all good art is French, but they do believe that all good art finds its way to Paris and there receives its honours. The mood is reflected in the standards of contemporary art criticism. It is hard to believe that the language used is the same as that in which the philosophers write. It iş a language of loose rhetoric and inaccurate recipes. André Malraux is a talented example. It is also reflected in the evident snobbery to be found in so much cultural discussion – the outstanding exceptions being not communists but, quite simply, the young. In France it is believed that there are no questions about art which have not already been fully answered there.

Thus Picasso found himself confined within the prejudices of his new comrades – in France in one way, and in the socialist countries in another. Endless debates were carried on about how art could serve the needs of the workers of the world, and with each debate the range of the argument became narrower, the diversity of the world more forgotten.

If this had not been so, if the cultural views of Moscow and Paris had been less nationalistic and less proud, some comrades might actually have analysed Picasso's work – instead of only being concerned with disclaiming or claiming it. They would then have discovered in what manner he was exiled, and this could straightaway have suggested how his genius could be both saved and used.

Picasso should have left Europe, to which he has never properly belonged, in which he has always remained a vertical invader. The world communist movement with its internationalism and (at least at the rank-and-file level) its true fraternal sense of solidarity, was ideally suited to enable Picasso to travel on the terms he needed – that is to say as an artist, a seer, searching for his unique people in whose name he might speak.

He might have visited India, Indonesia, China, Mexico, or West Africa. Perhaps he would have gone no farther than the first place. I have no idea which country or continent he would have chosen. Nor am I suggesting that he would necessarily have settled outside Europe. I am suggesting that outside Europe he would have found his work. His unusual speed of assimilation, the complex cross-breeding of his own cultural heritage, the intense

178

physical basis of his art, the debt of his most personal style to non-European traditions of painting and sculpture, his newly acquired political convictions, the very nature of his genius as we have examined it in this essay – all would have specially qualified him to become the artist of the emerging world, challenging the hegemony of Europe.

Unfortunately we cannot create even in our minds the Picassos that have not been painted. Picasso hates travelling. He has, for instance, only been to Italy once. He has never left Europe. But the opportunities were so wide, and at first Picasso's enthusiasm for a new life, a new struggle, was also so great!

It could have been the first time in the history of art that an artist was commissioned according to the needs of his own genius. The paintings, by the simple fact of being painted, could have given substance to a thought, a hope of Aimé Césaire's, which is fundamental to our time:

> . . . for it is not true that the work of man is finished
> that we have nothing to do in this world
> that we are the parasites of our world
> that all we must do is keep in step with the world
> no the work of man has only just begun
> and it remains for man to conquer all the restrictions
> standing so firm at the corners of his fervour
> no race has the monopoly of beauty, intelligence or
> strength
> there is room for all at the meeting place of
> conquest. . . .

Above all, these works, which do not exist, could have meant the triumph of a great artist's late period – the full use of Picasso's genius at the height of its power.

As it was, he became a national monument and produced trivia.

The mounting horror of the last fifteen years of Picasso's life can be glimpsed between the lines of all those who, having visited the monument, write down their impressions for newspapers. All that they have to offer is gossip. Even a serious scholar like John Richardson is reduced to describing what Picasso wears and eats for breakfast. In the end one is forced to accept that there is nothing else to describe. Why

179

then describe it? Because Picasso is a celebrity, floodlit with a lighting that from the spectator's point of view makes everything significant. People, and even genuine friends of his, press near so that some of the light can fall on their faces too.

If you should wish to know of the horror of such a life in detail, I recommend the book *Picasso Plain* by Hélène Parmelin.* Most of what it reveals is unintentional. The author is the communist wife of a communist painter and a close friend. The book is about Picasso's life in the fifties. It is dedicated to *the King of La Californie*. La Californie was Picasso's house in Cannes. Picasso is the King.

Picasso is the king. Everything and everybody revolves round him. His whim is law. No word of criticism is ever heard. There is a great deal of talk but very little serious discussion. Picasso behaves and is treated like a child who has to be protected. It is perfectly in order to like one picture better than another. But it is inconceivable that anybody should suggest that any painting is a total failure. There is no sense whatsoever of a struggle towards an aim: only a sense of Picasso struggling blindly within himself, and everybody else struggling to keep him amused and happy. Manners are informal but the degree of self-abnegation byzantine. Madame Parmelin tells a story that demonstrates this – almost incredibly. She was having a bath in a room off Picasso's studio. Unexpectedly he returned with some visitors. She had no clothes with her and the only way out was through the studio. Rather than shout and ask for a towel she sat shivering for three quarters of an hour and caught influenza.

The horror of it all is that it is a life without reality. Picasso is only happy when working. Yet he has nothing of his own to work on. He takes up the themes of other painters' pictures (Delacroix's *Femmes d'Alger*, Velazquez's *Las Meninas*, Manet's *Déjeuner sur l'herbe*). He decorates pots and plates that other men make for him. He is reduced to playing like a child. He becomes again the child prodigy. The world has failed to liberate him from that state because it has failed to encourage him to develop.

Outside his studio it is no more real. In his house he is

* Secker & Warburg, 1963.

surrounded by acolytes and flatterers. Outside his house he is a benign god who brings luck to all those who are living in the same town or dining in the same restaurant. But who among them takes him seriously? As a communist? As a painter for them? He is liked, perhaps even loved, because he is a benefactor; he brings honour and prosperity; he gives away autographs and drawings and the chance of having spoken to him.

To fill the vacuum left by reality, it is necessary to invent. His life is full of fantasies and specially created dramas. I do not speak of his subjective life, but the daily life in his household. There are invented characters, invented rituals, invented turns of phrase. Nothing, as it were, remains standing on the floor. Everything is lifted up and made 'truer than life' by his devotees, so that he shall never feel lost in emptiness. One is reminded of the last days of some old vaudeville star: everything, creaking now, is still *invented* as superlative. But there is one great difference: old vaudeville players go on performing till they drop. The tinsel is to keep them going, not to distract them.

So complete is the loss of reality and so frenetic are the efforts of all those around him to keep him feeling and being great that Picasso himself is no longer believed. A man who has trusted his own sensations as he has done knows the extent to which things have gone. He is desperate. The last thing he says in Parmelin's book is: 'You live a poet's life and I a convict's.' But she, in her usual state of euphoria induced by believing that she is the great man's confidante, thinks that this is just Picasso being Picasso.

At this point I may be accused of being too imaginative. I talk of pictures that Picasso *might* have painted in India. I describe to you Picasso's inner state of mind without having met him and in the face of the evidence of those who write about him as friends. My justification is that what I have deduced is the result of trying to relate *all* the facts that can be publicly known about Picasso. So often important ones are hidden or ignored.

Painters, unlike a certain kind of poet, need time to develop and slowly uncover their genius. There is not, I think, a single example of a great painter – or sculptor – whose work has not gained in profundity and originality

181

102
Delacroix.
Les Femmes
d'Alger. 1834

103 Picasso.
Les Femmes
d'Alger. 1955

as he grew older. Bellini, Michelangelo, Titian, Tintoretto, Poussin, Rembrandt, Goya, Turner, Degas, Cézanne, Monet, Matisse, Braque, all produced some of their very greatest works when they were over sixty-five. It is as though a lifetime is needed to master the medium, and only when that mastery has been achieved can an artist be simply himself, revealing the true nature of his imagination.

However favourably one judges Picasso's work since 1945 it cannot be said to show any advance on what he created before. To me it represents a decline: a retreat, as I have tried to show, into an idealized and sentimental pantheism. But even if this judgement is mistaken, the extraordinary fact remains that the majority of Picasso's important late works are variations on themes borrowed from other painters. However interesting they may be, they are no more than exercises in painting – such as one might expect a serious young man to carry out, but not an old man who has gained the freedom to be himself.

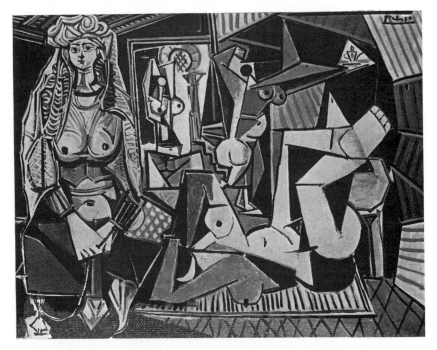

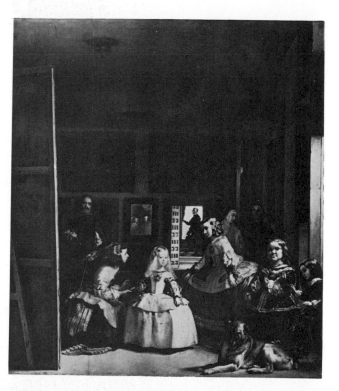

104
Velazquez.
Las Meninas.
1656

105 *Picasso.*
Las Meninas.
1957

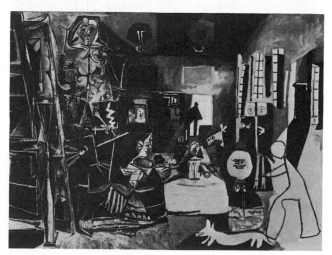

184

It is sometimes claimed that Picasso only takes Delacroix or Velazquez as a starting point. In formal terms this is true, for Picasso often reconstructs the whole picture. But in terms of content the original painting is even less than a starting point. Picasso empties it of its own content, and then is unable to find any of his own. It remains a technical exercise. If there is any fury or passion implied at all, it is that of the artist condemned to paint with nothing to say.

Notice in his variation on the Velazquez how extreme the distortions and displacements are. The dwarf, the dog, the painter are wrenched out of Velazquez's hands – but for what reason, to express what? One has only to compare any of these figures with the *Bullfight*, painted twenty years

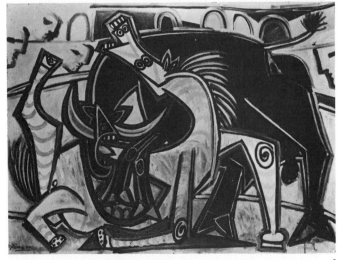

106 *Picasso. Bullfight.* 1934

before, to be reminded of how intensely Picasso once used distortions to communicate experience.

The violence, it seems, is only to rob Velazquez: to honour him perhaps at the same time as robbing him; even – and again like a child – thus to ask for his protection. In his own painting Velazquez is so effortlessly himself, and in Picasso's painting he is so overwhelmingly large, that he might be a father. It may be that as an old man Picasso here returns as a prodigal to give back the palette and brushes he had acquired too easily at the age of fourteen. Perhaps this last large painting of Picasso's is a comprehensive admission of failure. Perhaps this is only a minute

185

part of the truth, or none of it at all. But what is certain is that neither Picasso's *Las Meninas* nor any of his late paintings are the mature work of an old painter, at last able to be himself. What is certain is that Picasso is a startling exception to the rule about old painters.

Why has nobody pointed this out? Why has nobody considered Picasso's likely desperation? Apparently it is not only in his own household that nobody dares to mention the word failure. Apparently we need to believe in Picasso's success more than he does himself.

Towards the end of 1953 Picasso began a series of drawings. At the end of two months there were 180 of them. Drawn with great intensity, they are autobiographical; they are about Picasso's own fate.

When they were first exhibited and published, their general character was recognized. Besides praising the 'exquisite use of line', people talked of an 'emotional disturbance', etc. But then, *in order not to understand what the drawings confessed*, everyone pretended that their meaning was so complex and mysterious and personal that it would be impertinent to try to put it into words. Enough to declaim once more: Picasso! And after having admired the brilliance, to forget everything but his 'greatness'. (The greatness that had ground him to a standstill.)

It is true of course that for Picasso each of the drawings must have had several levels of meaning and hundreds of stray associations. But it is equally true that the theme of the confession as a whole is quite unambiguous.

In nearly every drawing there is a young woman. Not necessarily the same one. Usually she is naked. Always she is desirable. Sometimes she is being painted. But when this happens, one scarcely feels that she is posing. She is *there* -- just as she is *there* in the other drawings; her function is to be. She is nature and sex. She is life. And if that sounds a little ponderous, remember that it is for the same elemental reason that all drawing classes from the nude model in all art schools are called Life Classes.

Beside her Picasso is old, ugly, small, and – above all – absurd. She looks at him not unkindly, but with an effort – as though her concerns were so different from his that he is almost incredible to her.

186

He struts around like a vaudeville comedian. (The comparison I made a few pages back is one that has occurred to Picasso too.) She waits for him to stop.

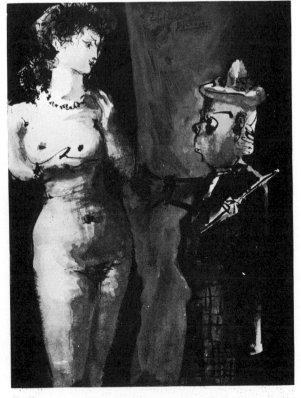

To hide himself and at the same time to mock himself he puts on a mask. The mask emphasizes that whereas all her pleasure in physical being and in sex is natural, his, because he is old, has become obscene. Next to the young woman is an old one. In another drawing the young and the old women sit side by side. Picasso is confessing his horror at the fact that the body ages and the imagination does not. When the whole energy of life has been found in the form of resilience of a body – how is it possible to endure the continuing need for that consoling energy when the form begins to collapse?

108 *Picasso.*
Young
Woman and
Old Man
with Mask.
23 December
1953

He begins to envy the monkey – the monkey who so early in Picasso's work was a symbol of freedom. He envies it because the young woman plays with it. But, more profoundly, he envies it because, unselfconscious, it pursues its desires without any sense of absurdity: on the contrary, with a complete sense of absorption which then, despite the ugliness of its body, compels the young woman to delight in it.

109 *Picasso. Young Woman and Monkey. 3 January 1954*

He returns to the idea of the mask, this time seeking comfort from the conceit that it is his old age which is the mask: and that behind it he is as young as ever. A young Cupid holds the mask in front of him. It represents both the old man's face and his genitals: a pun which Goya used in some of his etchings and which Picasso surely remembered, but also a lonely, nostalgic variation on the theme of that composite lover's head whose sweet smile was once all sexual pleasure.

110 *Picasso. Young Woman and Cupid with Mask.* 5 January 1954

The Cupid, with the old man's face and organ, courts her. The race, the panting begins. Again the absurdity, the slavery of the situation haunts Picasso.

111 *Picasso.*
Young
Woman with
Cupids.
5 January
1954

He draws a monkey, like a jockey, riding a horse. Then a woman, like Godiva, riding a toy horse. Later, in a world where everything is soiled, the monkey jerks himself up and down on a donkey's back whilst a clown and a girl acrobat gaze as though sadly accepting as a truth such pointless slavery to sex.

112 Picasso
Girl, Clown,
Donkey, and
Monkey.
10 January
1954

To escape from the slavery Picasso thinks again of the pleasures. Summoning up the acrobats of his youth, he turns their ease into a metaphor of free enjoyment.

The memory of such happiness rides him on remorselessly.

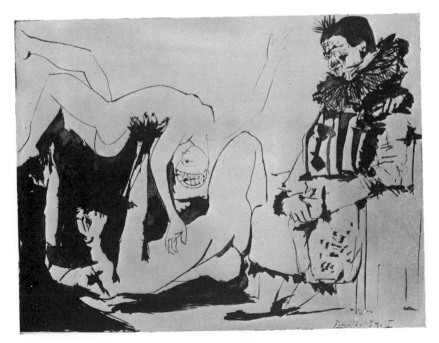

193

Now he grasps at that shared subjectivity which is unique
to sex and to which he had dedicated so many paintings.
By the logic of this sharing she will wear his mask – the old
man's crumpled one – and he will wear her mask, eye open
and fringed with lashes. Here, if the picture could become
reality (and metaphorically it could), is true happiness.
The horror is that the monkey remains. He sits there behind
them and looks away because such sentimental illusions
are of no interest to him. They have no substance and no
weight.

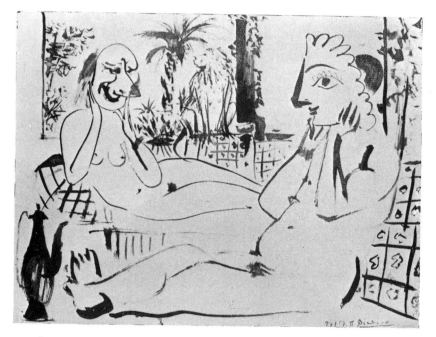

114 *Picasso.*
Couple with
Masks.
24 January
1954

On the next day, the 25th of January, 1954, Picasso, all his imagination now roused, dismisses the monkey and pursues the logic of his fantasy further. As the masks are swapped, they can also be transformed. He wears the mask of the young girl representing her almost as she is. She wears his mask, but instead of representing him as an obscene old man, it has become the mask of a virile young god. And so they play a charade (a charade that is played in many hotel bedrooms every night). Yet at the same time the prodigy in Picasso, the *duende* that possesses him, insists upon his telling the truth. He draws himself playing the charade so earnestly that he looks absurd. And he draws her kneeling indulgently so as to be on his level, playing as with a child to keep him happy.

115 *Picasso.
Old Man and
Young
Woman with
Masks.
25 January
1954*

116 *Picasso.*
Girl, Clown,
Mask, and
Monkey.
25 January
1954

Finally, one of the last drawings of the series shows the vanity of any attempt at escape from the absurdity of the situation. The mask – a symbol now for all that imagination can construct and subjectivity enjoy – is shown to the triumphant monkey. The monkey gazes at it blankly. The mask is held by a sad clown, whose own face is made up as though it too were a mask. But the monkey sits on its haunches beside the legs of the young woman, ready at any moment to jump into her lap and there be welcome.

Thus far one might consider this series of drawings as a very poignant and bitter lament for lost youth, and a protest against the savage sexual deprivation of old age. I think often, as I look at them, of Yeats. (Somehow, in a way that I have not yet fully understood, many connexions suggest themselves between Picasso and Yeats: the paintings of the one frequently evoke the poems of the other.)

> 'Because I am mad about women
> I am mad about the hills,'
> Said that wild old wicked man
> Who travels where God wills.
> 'Not to die on the straw at home,
> Those hands to close these eyes,
> That is all I ask, my dear,
> From the old man in the skies.
> *Daybreak and a candle-end*

> 'Kind are all your words, my dear,
> Do not the rest withhold.
> Who can know the year, my dear,
> When an old man's blood grows cold?
> I have what no young man can have
> Because he loves too much.
> Words I have that can pierce the heart,
> But what can he do but touch?'
> *Daybreak and a candle-end*

But Picasso's confession is even more comprehensive and more tragic. For, apart from the directly sexual theme, there

is another, parallel to it, but with different implications. Throughout the whole series of drawings Picasso turns from one to the other, as though they were different aspects of the same reality. The second theme is that of the artist and his model.

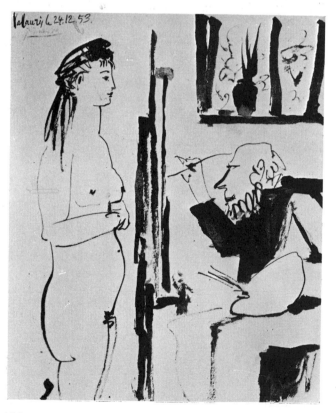

The model is the same young woman – in so far as she too is sex, nature, life. And the painter, though sometimes he is depicted as old and sometimes young, sometimes thin and sometimes fat, is the same man in so far as he is absurd and helpless. The complaint is different. It is no longer that an old man's desires are obscene and absurd despite himself: it is that to *paint* in front of such a young woman, to put marks on canvas and to peer at her proportions, instead of making love to her, is also absurd, and absurd in such a dry, pedantic way that it too becomes obscene.

118 *Picasso. Painter and Model. 25 December 1953*

Thus the role of the young woman remains very similar. Her youth, her beauty, her natural appetites, her tenderness and all that makes her desirable are there to mock all men who cannot or will not take her on her own terms: and those terms are both as perfect and as ruthless as nature. For her, old age is a debility and a hindrance, an act of imagination is a transitory game, art is an incomprehensible – at best harmless – way of passing the time. Her true companion is the monkey. Finally she chooses him instead of the man, or at least in proxy for the man who is eternally incapacitated.

119 *Picasso.*
Woman,
Apple,
Monkey,
Man.
26 *January*
1954

Perhaps the bitterest drawing of the whole series is that in which the monkey pretends to paint, and where, for the first time, the young woman, instead of looking indifferent whilst being painted, responds to him and smiles. The degree to which that response mocks us is shown by Picasso in the pun that he has drawn between her breast and his muzzle. Many have called this witty. It is witty, but it is a wit born out of much suffering.

120 *Picasso.*
Woman and
Monkey
Painting.
10 January
1954

In his old man's confession, Picasso confesses to despair. It is not the social despair of Goya; it is a despair confined and belonging to his own life. The drawings are like a retrospective exhibition of that life. The despair is to some extent qualified by the fact that he can express it. But it remains.

It is the despair of the idealized 'noble savage' who, alone, abstracted from history and insulated from any social reality, is forced back and back until finally he is left with all his imagination unaccounted for by the pure nature which he must worship. The monkey who was once his companion in freedom, a dumb critic of society by the side of a more articulate one, becomes in the end his rival and humiliator. His gifts become his absurdity. Nor is it that he simply considers his own work a failure. It is the very idea of art which is attacked – attacked by Nature, with which now as an old man, without a unique people and so without any true followers, he has been left utterly alone. He himself now believes in this attack and actually sides with Nature against art because civilization, as he has found it, has given him only one thing: acclaim.

The gifts of an imaginative artist are often the outriders of the gifts of his period. Frequently the new abilities and attitudes become recognizable in art and are given a name before their existence in life has been appreciated. This is why a love of art which accompanies a fear or rejection of life is so inadequate. It is also why ideally there should always be a road open to art even for those to whom the medium, the talent, the activity involved mean nothing. Art is the nearest to an oracle that our position as modern scientific men can allow us.

What happens to an artist's gifts may well reveal, in a coded or cyphered way, what is happening to his contemporaries. The fate of Van Gogh was the partial fate of millions. Rembrandt's constant sense of isolation represented a new intimation of loneliness experienced, at least momentarily, by hundreds in seventeenth-century Holland.

And so it is with Picasso. The waste of his genius, or the frustration of his gifts, should be a fact of great significance for us. Our debt to him and to his failures, if we understand them properly, should be enormous.

Picasso has remained a *living* example, and this involves far more than not dying. He has not stopped working. He has not lied. He has not allowed his personal desperation to destroy his vitality or his delight in energy. He has not become politically – and therefore humanly – cynical. He has never, in any field, become a renegade. We cannot write him off. He has achieved enough to show us what he might have achieved. Because he is undefeated, he remains a living reproach. But a reproach against what?

Picasso is *the* typical artist of the middle of the twentieth century because his is the success story *par excellence*. Other artists have courted success, adapted themselves to society, betrayed their beginnings. Picasso has done none of these things. He has invited success as little as Van Gogh invited failure. (Neither was averse to his fate, but this was the limit of their 'invitations'.) Success has been Picasso's destiny, and that is what makes him the typical artist of our time, as Van Gogh was of his.

There have been – and are – many fine contemporary artists who have not achieved success, or, as we say, the success they deserve. But nevertheless they are the exceptions – sometimes because, courageously and intelligently, they have wanted to be so.

Consider how in the last twenty years the rebels and iconoclasts of the years before have been honoured! Not to mention traditionalists like Bonnard and Matisse. Or consider the phenomenon from the consumers' rather than the producers' point of view. Art, and especially 'experimental' art, has now become a prestige symbol, taking the place, in the mythology of advertising, of limousine cars and ancestral homes. Art is now the *proof* of success.

It would be too far outside the scope of this essay to explain why this has happened or to discuss the accompanying bitter contrast between the fortunate and unfortunate among artists. In a competitive society rewards such as are now offered for art are bound to mean an immense and uneconomic number of underprivileged hoping against hope for their chance.

The fact remains that since the French Revolution art has never enjoyed among the bourgeoisie the privileged position it does today. Once the bourgeoisie had their own artists and treated them as professionals: like tutors or

203

solicitors. During the second half of the nineteenth century there was also an art of revolt and its artists were neglected or condemned until they were dead and their works could be separated from their creators' intentions and treated as impersonal commodities. But today the living artist, however iconoclastic, has the chance of being treated like a king; only, since he is a king who is treated rather than who treats, he is a king who has lost his throne.

All this is reflected in the way artists talk amongst themselves and judge one another. Success is simultaneously desired and feared. On one hand it promises the means to survive and go on working; on the other it threatens corruption. The most frequently heard criticism is that, since his success, X is repeating himself, is merely picture-making. But the problem is often seen too narrowly as one of personal integrity. With enough integrity, it is suggested, one should be able to steer an honest course between success and corruption. A few extremists react so violently that they actually believe in failure. Yet failure is always a waste.

The importance of Picasso's example is that it shows us how this fundamental problem of our epoch is an historical and not a moral one. Because Picasso does not belong to Western Europe we can appreciate how unnatural his success has been to him. We can even imagine the kind of *natural* success which his genius needed.

Furthermore we can see very precisely how the success which he has suffered has harmed him. It would be quite wrong to say that Picasso has lost his personal integrity, that he has been corrupted; on the contrary, he has remained obstinately true to his original self. The harm done is that he has been prevented from developing. And this has happened because he has been deprived of contact with modern reality.

To be successful is to be assimilated into society, just as being a failure means being rejected. Picasso has been assimilated into European bourgeois society – and this society is now essentially unreal.

The unreality, although it affects and distorts manners, fashions, thoughts, is at base economic. The prosperity of capitalism today depends, through investment, on the raw materials and labour of the under-privileged countries.

But they are far away and unseen – so that at home most people are protected from the contradictions of their own system: those very contradictions from which all development must come. One could well talk of a drugged society.

The degree of torpor is particularly startling in Britain which, not so long ago, was known as the 'workshop of the world'; but with variations the same trend governs all capitalist countries. In the *Financial Times* in 1963 the twenty largest British monopolies were listed. Their total net profits were £414 million. Of this figure *two-thirds* came from enterprises involved in overseas exploitation (oil, tobacco, rubber, copper, etc.) whilst profits from heavy industry in Britain were no more than £18.7 million and from light industry only £43 million.

The ideological effects of such stagnation are so immediate and pronounced because of the stage of knowledge which we have now achieved. Once it was perfectly possible to live off the loot of the world, to ignore the fact, and still to make progress. Now it is impossible *because the indivisibility of man and his interests and the unity of the world are essential points of departure in every field of thought and planning*, from physics to art. That is why the average level of cultural and philosophic exchange in the West is so trivial. It is also why such progress as is being made is made in pure science, where the discipline of the method forces researchers to jettison, at least whilst working, the habitual prejudices of the society they find themselves in.

The young, those who are still anonymous in a society which imprisons with names and categories, sense the truth of all this, even if they do not explain it. They suspect that the rich are now neurotic and daily getting worse. They look round at the faces in an expensive street and know that they are ignoble. They laugh at the hollowness of formal, official ceremonies. They realize that their democratic choice exists only in theory. They call life the rat-race. They regret that they haven't had time to find an alternative.

The example of Picasso is not only relevant to artists. It is because he is an artist that we can observe his experience more easily. His experience proves that success and honour, as offered by bourgeois society, should no longer tempt anyone. It is no longer a question of refusing on principle, but of refusing for the sake of self-preservation.

The time when the bourgeoisie could offer true privileges has passed. What they offer now is not worth having.

The example of Picasso is also an example of a failure of revolutionary nerve – on his part in 1917, on the part of the French Communist Party in 1945. To sustain such nerve one must be convinced that there will be another kind of success: a success which will operate in a field connecting, for the first time ever, the most complex imaginative constructions of the human mind and the liberation of all those peoples of the world who until now have been forced to be simple, and of whom Picasso has always wished to be the representative.

INDEX

INDEX

discontinuity of his work, 37–8
end of his isolation, 73–4
example of, 202–6
his exile, 15, 93, 140, 173, 175, 202
fear of blindness, 43–4, 72
historical ambiguity of, 13
humanism of, 115
as an impersonator, 94–8
influence of African masks on, 73
influence of archaic Spanish sculpture on, 73
intensity of his art, 30, 32, 168
his irrationalism, 32, 34
the legend, 5–15
loneliness of, 15–16, 42, 83, 179–81
as a magician, 92, 98–102
market prices, 3–5
as the Minotaur, 104
as a national monument, 179–81
nature of his genius, 32, 38, 120, 126, 130–1, 172, 202
as Pan, 111
and the portrayal of pain, 148, 168–9
on research in painting, 29–30
and sensation in art, 107–11
sexuality of his art, 156–62
unchanged vision of, 35
work since 1945, 183–6
and world communist movement, 175–8
Pottery, 100–1
Poussin, Nicholas:
Triumph of Pan, 106–7
Prodigies in art, 28–9

Quantum mechanics, 68–9

Raynal, Maurice, 14
Rembrandt, 202
Revolutionary thought:
bourgeois, 122–4, 172
proletarian, 124–6, 172
Richardson, John, 179
Romanticism:
attitude of to work, 10
Rousseau father of, 123
vision of the future, 12
Rousseau, Jean-Jacques, 121–4
Rusiñol, Santiago, 24

Sabartes, Jaime, 8
Salmon, André, 60
Schiele, Egon, 104
Scientific thought, revolution in, 66
Sex, shared subjectivity of, 158–60, 194
Sexuality in art, 156–7
Siqueiros, David, 166–7
Soviet Union:
art policy of, 177
attitude to Cubism, 70
Picasso's reputation in, 175–6
Spain:
and anarchism, 22–4, 43
Civil War in, 23, 130, 164–6, 172
contribution of to culture, 16–17
and the duende, 38–40
feudalism of, 18–19, 22
historical character of, 16–27
middle classes in, 19–22
Subject-matter of art:
new subjects, 140–2
social functions of, 133–6
Symbolists, 54

209

ABOUT THE AUTHOR

John Berger was born in London in 1926 and is renowned as a
novelist and writer on art. His many books, innovative in form
and far-reaching in their historical and political insight, include
the award-winning novel G; imaginative documentaries, such
as A Fortunate Man; and such unique studies of art as the
internationally-acclaimed Ways of Seeing. Respected for his
uncompromising judgements on art, Berger is seen by many as
Britain's most influential art critic. Over two decades, he has
made an original socialist vision of art accessible through
numerous articles in New Society and The New Statesman;
while his Permanent Red, Success and Failure of Picasso and
Art and Revolution are today classics of art criticism. Berger has
also written several film scripts and created pioneering pro-
grammes for television.

John Berger lives at present in a small peasant community in
France which is the setting for his latest fiction, Pig Earth, the
first part of a projected trilogy entitled Into Their Labours.